The Art of Benin

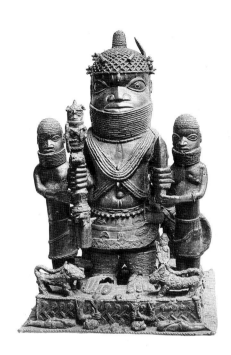

The Art of Benin

REVISED EDITION

PAULA GIRSHICK BEN-AMOS

SMITHSONIAN INSTITUTION PRESS
WASHINGTON, D.C.

Published in the United States of America by
Smithsonian Institution Press

ISBN 1-56098-610-7

Library of Congress Catalog Number 95-68000

Published in Great Britain by
British Museum Press, London

Typeset in Great Britain by
Rowland Phototypesetting Limited,
Bury St Edmunds, Suffolk

Printed and bound in Spain
by Imago Publishing Limited

00 99 98 97 96 95 5 4 3 2 1

Front cover: Brass commemorative head for the altar of a Queen Mother. See fig. 22.

Back cover: Ivory leopard. See fig. 71.

Half title: See fig. 35.

Title spread: See fig. 15.

Pages 4–5: See fig. 60.

CONTENTS

ACKNOWLEDGEMENTS

I would like to acknowledge the help of the late Ọba Akẹnzua II and late Chiefs Ihaza, Inẹ n'Igun, Ovia Idah, Ihama n'Igun Ẹrọnmwọn, and Ọbamwọnyi of Ogbelaka. My thanks go also to the current Ọba, Ọmọ n'Ọba n'Ẹdo Uku Akpọlọkpọlọ Erediauwa. My research was greatly assisted by the craftsmen Chief Ohanbamu Inẹ and David Ọmọregie of Igbesanmwan, Izevbokun Ọbazona of Owinna n'Ido, Aguẹbo Osaguẹ of the Benin Divisional Council and their fellow craftsmen, Chiefs Aigbe of Eha Quarter, Uselu, Eghobamien and Osuan, and the religious specialists Ohẹn Azaigueni Aghahowa and herbalist Aikaronẹhiọmwan Isibo. Over the years, generous assistance was provided by Dr. Rebecca Agheyisi, Chief Michael Ojomoh and Ikpemwosa Ọsẹmwẹgie. A special debt of gratitude goes to my research assistant, Osarenren Omoregie, for his friendship and dedicated efforts to record Ẹdo history and culture. The Universities of Ibadan and Benin provided research affiliation and the Bendel (now Ẹdo) Arts Council supplied important information. Most of the field photographs were made by Dan Ben-Amos.

My research has been funded at different times by the Foreign Area Fellowship Program, the Social Science Research Council, the American Philosophical Society, the Marsden Foundation, and the National Endowment for the Humanities. The first edition of this book was written while I was a Mellon Fellow in the Humanities at the University of Pennsylvania. I am grateful to all these sponsors.

This book builds on the pioneering efforts of the late R. E. Bradbury and its preparation was assisted in various ways by Barbara Blackmun, Ros Bradbury, Justine Cordwell, Kathy Curnow-Nasara, Sara Dickerson, the late Douglas Fraser, Philip Dark, the late William Fagg, Ilana Gershon, Rosalind Hackett, Alan Ryder, Roy Sieber, Sonia Silva, John Thornton and Frank Willett. The help and cooperation of John Mack, Nigel Barley and Alison Deeprose of the Museum of Mankind, Jeremy Coote of the Pitt Rivers Museum, Oxford, Kate Ezra, formerly of the Metropolitan Museum of Art, New York, Christraud Geary and Janet Stanley of the National Museum of African Art, Washington, D.C., Janet Landay of the Houston Museum of Fine Arts, Armand Duchâteau of the Museum für Völkerkunde, Vienna, Peter Göbel of the Museum für Völkerkunde, Leipzig, and Lorenz Homberger of the Museum Rietburg, Zürich are greatly appreciated. Finally, it was a pleasure to work with as skilled an editor as Carolyn Jones of the British Museum Press.

PREFACE TO SECOND EDITION

During the fifteen years since this book was first published, there has been a flowering of research in the study of Benin art. One gauge of this is the list of forty or more books and articles, nearly all of recent date, which I have added to the bibliography. In addition, in the past few years a number of exhibitions of Benin collections have circulated in Europe and America and several major museums have redone their permanent galleries. All of this suggests that an updated version of the book would be in order.

The main changes and additions to the original text will be found in the Introduction, to take account of studies on artistic creativity and gender, and in the first chapter, to include an increase in research on the history of both brass and ivory art forms, as well as some information on contemporary developments. I have made numerous minor amendments throughout the book, although I have retained the general structure.

It was John Mack, Keeper of Ethnography at the British Museum, who provided the impetus for this new edition by initiating contacts between British Museum Press and myself and by generously providing illustrations from the British Museum collections. I am grateful for this opportunity to update the book and also to correct mistakes that crept into the first edition.

As with the first edition, I wrote this book for a general audience both here and in Nigeria. The scholarly references are kept to a minimum in the text but can be found in the footnotes and bibliography. The Ọbas, chiefs, artists and ritual specialists who so generously provided me with information on their culture and art did so with the express intent that it be preserved for their descendants, and I hope that in some small measure this book fulfils their wishes.

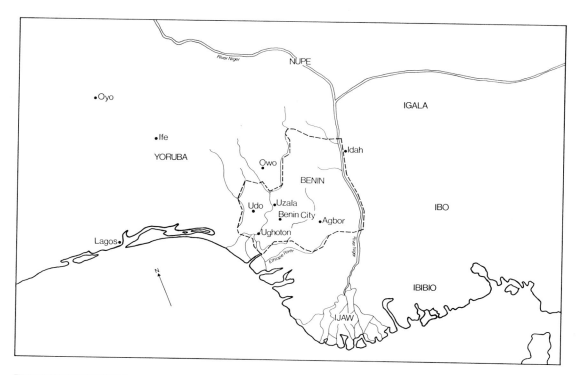

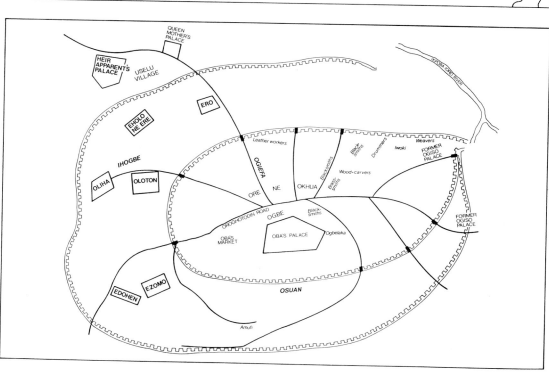

INTRODUCTION

The art of the Benin Kingdom came to public and scholarly attention in the West in 1897, when members of a British Punitive Expedition brought out thousands of objects as war booty. Through government and private sales, Benin sculpture soon found its way into museum and personal collections in England, Europe and America. The British conquest of Benin resulted not only in the dispersal of the artefacts themselves, but also in considerable changes in the fabric of Benin life. Once an independent warrior kingdom, Benin was now incorporated into the wider political framework of the British Protectorate of Nigeria and later the modern Nigerian state. Today Benin City, a thriving metropolis of around half a million people,[1] is the capital of the Ẹdo State of Nigeria.

What was the Benin Kingdom like before 1897? As yet we know little of its origins. Benin is located on a rolling coastal plain in an area of tropical rainforest. There is little in its geographical position to explain its development, for the lateritic soil and thick forest growth would not appear to facilitate agricultural production or trade and communications. Nevertheless, by the thirteenth or fourteenth century AD, a flourishing state existed – or so oral traditions and archaeological investigations would seem to indicate.[2] By the fifteenth century it was an expanding warrior kingdom, as we learn from this account by Duarte Pacheco Pereira, a Portuguese explorer who visited Benin in the 1490s. In his work *Esmeraldo de Situ Orbis*, he describes Benin:

> The Kingdom of Beny is about eighty leagues long and forty wide; it is usually at war with its neighbours and takes many captives, whom we buy at twelve or fifteen brass bracelets each, or for copper bracelets, which they prize more.[3]

The Portuguese, who were exploring the west coast of Africa in search of trade and converts, reached this area in the third quarter of the fifteenth century. 'Beny' or Benin, the name by which they knew it, is still used by us today, although the people call themselves, their language, their capital city and their kingdom 'Ẹdo'.[4]

From at least the fifteenth century, the core of Benin political, religious and social life was the divine kingship. The monarch, or Ọba, ruled by virtue of his descent from Oranmiyan, the legendary founder of the present dynasty. According to royal tradition, Oranmiyan was a prince from the Yoruba Kingdom of Ife who was invited to Ẹdo by Benin elders dissatisfied with their previous rulers, the Ogiso.[5] Like similar traditions among neighbouring Nigerian groups, this story of the external origin of the ruler sets him apart from the ruled, a separateness reflected in his

MAP 1 Map of the core area of the Kingdom of Benin.

MAP 2 Map of the Benin City prior to 1897, showing the positions of the guilds and chiefs' houses. Created by the late Ekhator Omoregie, the Ihaza of Benin (English translation by author).

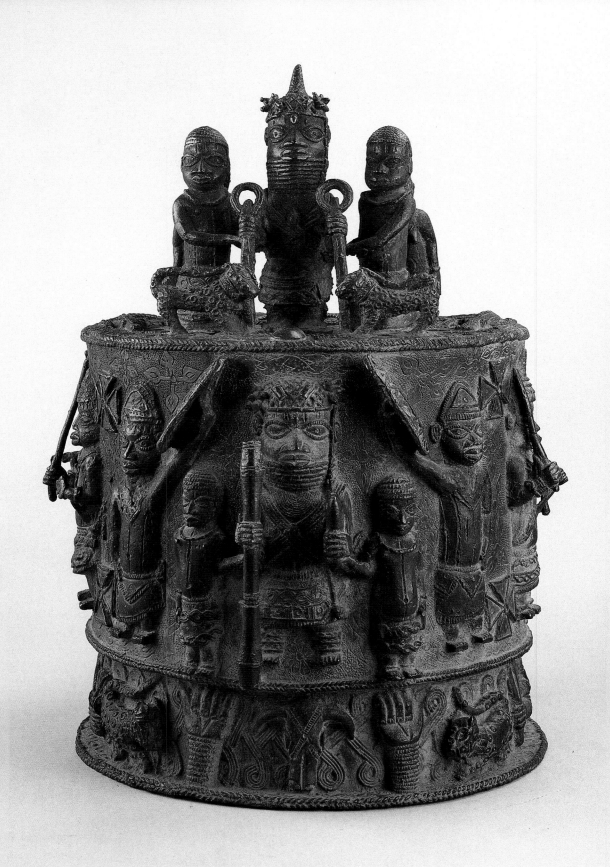

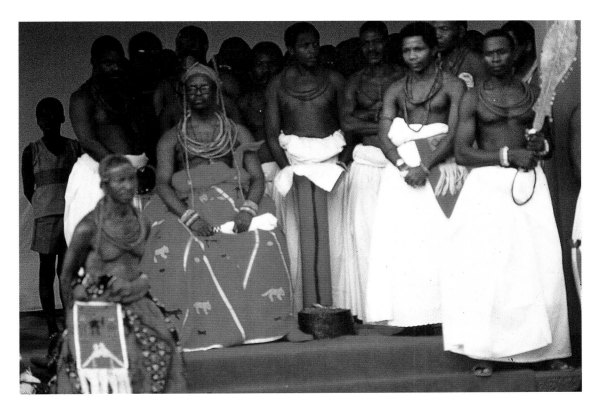

2 His Highness Ǫba Erediauwa at the Greetings Ceremony (Otuę) of Ugie
Erha Ǫba, the annual ritual honouring his ancestors, 1981.

1 Brass altar of the Hand (*ikęgobǫ*) made for an eighteenth-century king.
H. 47.5cm.

immense religious and political power.[6]

The religious basis of the Benin monarchy was noted by the earliest European visitors. In an account written about 1540 (published in G. B. Ramusio's *Navigazioni e Viaggi*, 1550), a Portuguese pilot portrayed divine kingship in Benin and neighbouring monarchies on the coast:

The kings are worshipped by their subjects, who believe that they come from heaven, and speak of them always with great reverence, at a distance and on bended knees. Great ceremony surrounds them, and many of these kings never allow themselves to be seen eating, so as not to destroy the belief of their subjects that they can live without food.[7]

The Ọba's political powers were extensive: he was the last resort in court matters and dispenser of the death penalty, the recipient of taxes and tribute, the controller of external trade, the titular owner of all the land in the kingdom, and the chief executive and legislator. Throughout Benin history there were, of course, both weak and strong Ọbas, but however much the effective political power of the ruler waxed and waned, the ideology of divine kingship appears to have remained central to Benin political life.

The Ọba's senior son was in theory his rightful heir, at least during the last two hundred years. Since, however, the king had many wives it often occurred that more than one gave birth at the same time, and thus it was difficult to determine which son really was the senior. For this reason, the brothers of an established Ọba – obviously potential rivals – were sent out to the countryside as hereditary rulers (Enigie) over administrative districts. The mother of the king was given the title of Queen Mother (Iyọba) and was set up in her own palace in the village of Uselu, just outside the city. There she functioned as a titled chief, with control over her own district, Iyekuselu, and the right to grant titles in her own court.

The king lived in a vast palatial compound covering several acres of land. This complex included meeting chambers for various groups of chiefs, storehouses, shrine compounds and work areas for ritual specialists and royal craftsmen, as well as a residential section for the Ọba's numerous wives and small children. The Ẹdo say 'In the Ọba's palace there is never silence', an adage which expresses well the hustle and bustle of activities carried on there by a multitude of officials, servants, family members and chiefs.

The exact form of Benin government may well have changed substantially over time, so that the following reconstruction of the past, based as it is on late nineteenth- and twentieth-century information, can only be tentative.[8] In the pre-colonial period, the

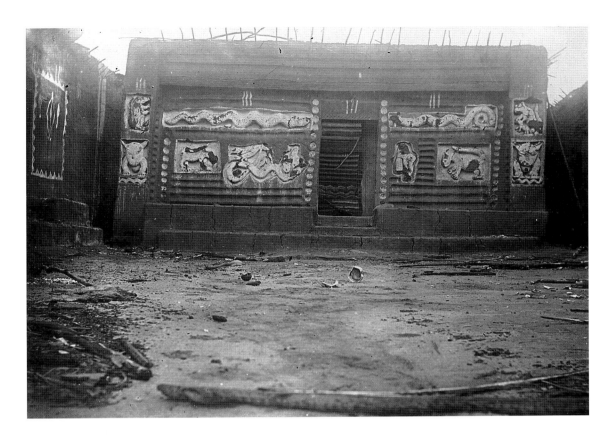

3 A traditional chief's house, photographed in 1897 by R. K. Granville. Architecture is one way of marking élite status. Chiefs own large compounds, the exterior walls of which are decorated with horizontal ridge designs (*agbẹn*). Formerly, clay bas-relief designs of animals, warriors, and other symbols of power were an important part of architectural decoration, but today this is rarely found.

titled chiefs, together with the royal family, constituted the political élite of the kingdom. The highest ranking among the chiefs were the Uzama n'Ihinrọn, Seven Uzama, who were considered to be the descendants of the very elders of Benin who had sent to Ife for Oranmiyan. As 'guardians of Benin custom', they had important rôles to play in the installation of new kings and the annual worship of the departed ones. The other title-holders – of which there were many – were broadly divided into Palace Chiefs, who lived in Ogbe, the king's sector of the city, and Town Chiefs, who lived across the main avenue in Ore n'Ọkhua (see Map 2). The Palace Chiefs consisted mainly of members of well-established urban families. They were concerned with the administration of the palace and belonged to one of three important palace associations: Iwebo, who cared for the Ọba's regalia, supervised his craftsmen and conducted negotiations with European traders visiting Benin; Ibiwe, who were in charge of caring for the Ọba's wives and children; and Iwẹguae, who provided the Ọba's domestic staff of officials, cooks, servants and pages.

By contrast with the Palace Chiefs, the Town Chiefs tended to be composed of men who rose to power by their own efforts, not through inherited wealth and connections. They were responsible for the administration of the various territories of the kingdom, including the collection of tribute, the conscription of soldiers and mediation between royal and village interests.

In the same area as the Town Chiefs lived numerous minor palace officials, chiefly retainers and members of guilds, of which there were about forty or fifty. Each guild was located in a special ward and had a specific service to perform for the king. Their duties were indeed diverse, ranging from leopard hunters (fig. 5) to drummers, astrologers and land purifiers. Among these guilds were the craftsmen who produced brass, ivory and wood sculpture, embroidered cloths and leather fans for the Oba and, with his permission, for the chiefs and priests in the city and throughout the kingdom (figs 6,7).

4 Parlour floor in a chief's house, Benin City, photographed in the 1950s. One of the special forms of decoration in a chief's house used to be a parlour floor embedded with cowrie shells, a pre-colonial type of currency. The design is of an Oba with mudfish legs holding crocodiles (compare fig. 17).

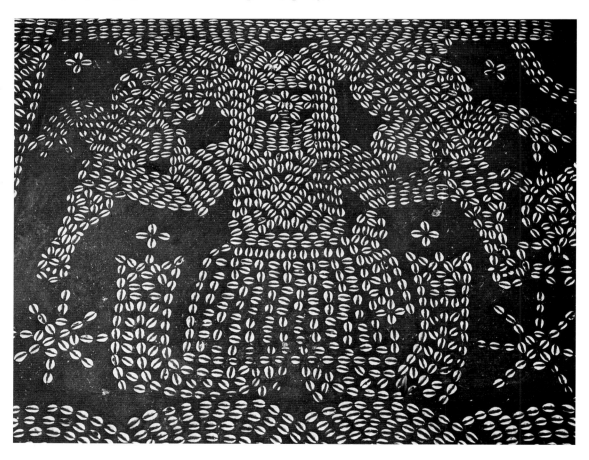

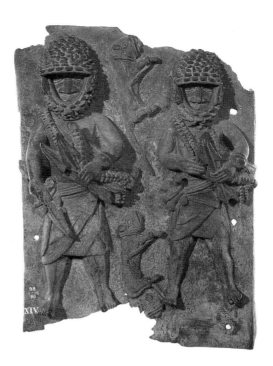

5 Brass plaque depicting members of the leopard hunter's guild. The leopard is considered the king of the forest and is thus a counterpart of the Ọba, the king of the settled land. Members of the guild captured leopards and kept them for royal sacrifice. Charms were used to tame leopards so that the king could parade in the city with them, a sign of his domination over the king of the forest. (See fig. 28). H 43cm.

These craftspeople constituted a kind of artisan class, for they lived in wards clustered in proximity with each other and preferred their children to marry those of other craftspeople. They were all considered 'servants of the Ọba', that is his special dependants. The Ẹdo adage 'Smiths and woodworkers will never suffer from poverty' expresses this continued (or at least expected) economic support.

Outside the capital, the population was settled in villages, some with only a few hundred people, others perhaps with several thousand. In the past some attained the status of towns or even small city states: for example, the name of the town Urhonigbe means 'ten gates' – a gesture of bravado aimed at Benin City, which had only nine. Oral traditions suggest that throughout Benin's history rural areas rose up in rebellion against the central government and much of the king's energies were spent in pacification.

Although these villages were mainly agricultural, some did specialise in crafts, such as the pottery centres of Oka, Use and Utekon, or the carpenters of Idunmwun-Owinna. With a few exceptions, such as these carpenters or the forgers of iron ceremonial swords from Iguẹbẹn, village craftsmen were not 'servants of the king', as were their urban counterparts. They worked instead for their own communities, carving masks for village cult rituals

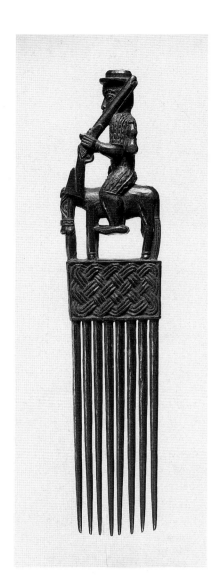

6 & 7 Guild craftspeople made not only religious and royal items but objects for daily use, such as this comb (6) and oil lamp (7). DIAM. of lamp 36.5cm.

and moulding life-size mud sculptures for local shrines. Creators of mud art, called ọmebọ (literally 'moulder of the gods'), were chosen by divine inspiration and often acquired reputations over a wide area of the kingdom (figs 48, 49).

Men had access to a greater range of artistic activities than did women in Benin.[9] Much of men's creative work took place within the guilds, where they cast, carved, forged and wove prestigious regalia and sculpture for the king and court. Outside the guilds, men worked iron, sculpted in wood and mud, created elaborate masquerade costumes and constructed and decorated shrines for a variety of village deities. Because of religious strictures preventing their handling metal or metal tools, women's participation was restricted to the weavers' guild, where they created elaborate ram's-hair ceremonial wigs for élite women and (together with men) woven hip pennants, and to the brass-casters' guild, in which in recent times female members have begun making highly-decorated ritual pots. Domestic weaving used to be an important women's craft until the early part of this century, and pottery making was – and still is – a female specialisation in a number of villages. This gender limitation broke down, however, in one important area of religious life: the worship of Olokun, god of the waters. Where his shrines were concerned, women were as active as men, creating the same art forms and even more. For Olokun, women moulded large mud figures, drew elaborate chalk designs, made pots and hung cloths to decorate shrines.

In whatever media they worked, artists saw themselves as possessing a body of forms and patterns that belonged to them and defined them as artists. The importance of these designs for artistic self-identity can be seen in the invocation that members of the carvers' guild make to their patron deity, Ugbe n'Owewe, upon commencing a carving: 'Ugbe n'Owewe, ancestors, let us prosper. Don't let us forget the patterns that we make. Don't let our children forget them.' These patterns were and still are seen as part of the guild heritage, handed down from generation to generation, through the inspiration of Ugbe n'Owewe. Outside the guilds, membership of an age grade, residence in a craft village or divine selection were the primary means of recruitment to artistic activity. Among these artists there was a similar sense of ownership of designs, although it was much less formalised than in the guilds. The chalk designers (ọwuorhue) for Olokun, god of the waters, for example, decorated the shrines with elaborate abstract designs, 'Olokun designs', that represent beings and objects in his undersea world (fig. 9).

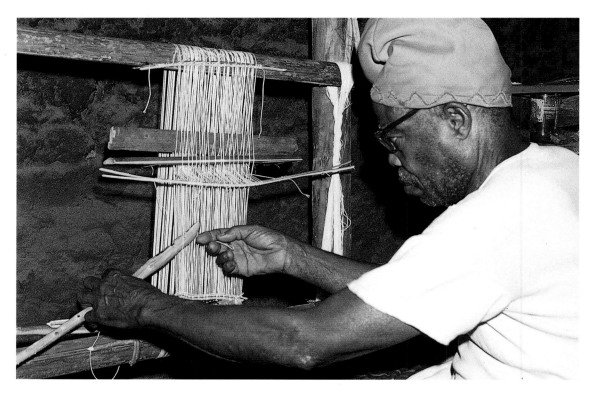

8 Izevbokun Ọbazona of Owinna n'Ido, the weavers' guild, making a waist pennant (*ẹgbẹle*). (See fig. 10).

Although they differed in the manner in which they acquired their skills, artists inside the guild and out shared a belief that the supernatural world was the ultimate source of their designs. In the very process of creation, artists worked in close contact with these divine beings, asking their favour, depending on their guidance and seeking their protection against accidents and witchcraft.

While there is no single word in the Ẹdo language that encompasses all that we consider to be 'art', there are ways of designating creative people and standards that are applied to forms. There are no 'artists' as a general category but there are weavers, potters, casters and so forth, all of whom have expertise in artistic production; they are skilled creators (*ọremwin-ẹsi ẹsi*), knowledgeable in technique, form and pattern. Done properly, their creations can be called *mosee*, which literally means 'beautiful', but has the connotations of 'proportionate', 'appropriate' and 'morally good'. Aesthetic criticism is part of the creative process: artists are evaluated and guided not just by their fellow artists but also by the ancestors or gods, who come to them in dreams. Those who are more skilled are acknowledged by other artists and by those who acquire or view their creations.

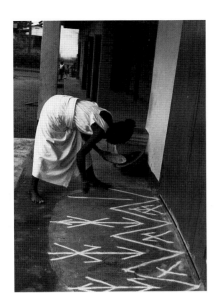

9 The chalk designer (*ǫwuorhue*) of Priestess Azaigueni Aghahowa, Benin City, decorating the entrance to her Olokun shrine.

The royal sculpture of Benin has attracted much attention in the near-century since it was first brought in quantity to the West. Indeed, a considerable body of scholarship has accumulated to which the reader can easily turn to find discussions about the origins and stylistic development of Benin art and its relation to other Nigerian artistic traditions.[10]

The aim of this book is to provide a broad perspective on Benin art in its historical and cultural context, based in large measure on materials gathered in the course of field research by myself and other scholars.[11] The starting point is the contemporary Ędo view of the history and meaning of their art. In a society as complex as Benin there are many different oral traditions about art, some of general currency, others held within special groups such as craft guilds. These traditions, when compared with European visitors' accounts and archaeological and ethnographic reports, can provide a provisional temporal framework for understanding the broad historical context in which Benin art was created. In like manner, the current meaning of Benin art forms can be found in the proverbs, tales and artistic commentaries of the Ędo themselves, as well as in the description and analysis of the various contexts – domestic as well as royal, rural as well as urban – in which these forms are used.

In trying to understand Benin art it is necessary to keep in mind that present interpretations are just that – present day interpretations. In the past, meanings may have been different; thus, for example, carved wooden heads found on chiefly ancestral altars (see fig. 67) are generally considered today as purely decorative commemorations of the deceased; however, an early seventeenth-century German visitor was told that these heads represented decapitated enemies, placed on the altar to boast of the late chief's accomplishments.[12] Thus, interpretations of Benin art are constantly in flux – created, revived, changed and negotiated – and those offered here can only be suggestive of past meanings.

It is not possible to cover fully the complexity of artistic production in Benin; this book can only be a beginning. The people of Benin are well aware of the intricacy of their culture and have a proverb that can serve as a reminder to us all:

A gha se Ędo, Ędo rree
The closer one gets to Benin, the farther away it is.

CHAPTER I
ART, HISTORY AND POLITICS

The Ẹdo are profoundly concerned with their past achievements, which, until recently, they preserved not in written records but in oral traditions.[1] Among these are lists of kings and detailed accounts of their wars, adventures and artistic innovations. The lists of kings provide a general historical framework, even though we do not know the exact dates of most of their reigns; the stories about their activities give us clues to the events of their times. Dominant traditions about political history are held within a small circle consisting of the Ọba, the Ihogbe priests (genealogists of the royal ancestors) and various title-holders, ritual specialists and craftspeople in the Benin court, and thus can be expected to present the royal view of the past. Alternative traditions do exist both within and outside the court and will be presented here wherever relevant.

As a result of European contact with Benin we have for the last four to five hundred years a remarkable collection of trade records, correspondence and, most especially, descriptions of Benin court life, customs and art. Using all these materials it is possible to sketch the broad outline of Benin artistic and cultural history. Obviously such a picture is much more reliable as we get closer to the present. For the remote past, we can only speculate on developments, relying on oral history and the preliminary results of archaeology.

The Ogiso Period and Early Benin Art

The Ẹdo view of the past is decidedly monarchical. From the very beginning Benin was ruled by a series of kings who were called Ogiso, or 'rulers of the sky'. Depending on the tradition, this dynasty consisted of thirty-one kings, or twelve, or just one.[2] A revolt by the Ẹdo removed the Ogiso dynasty from the throne. After a brief attempt at republican government the Ẹdo asked the King of Ife in Yorubaland for someone to rule them. He sent Oranmiyan, whose own son Ẹwẹka became the first Ọba in the dynasty which rules Benin today. By estimating the average reigns of Ọbas, scholars have suggested that the new dynasty was founded in the fourteenth century or somewhat earlier. The transition to this new dynasty symbolises a change in fundamental temporal and spatial orientation. The Ogiso period is archaic and essentially mythological. Neither strict chronology nor the exact number of kings is important. The second dynasty, in contrast, is founded on temporal duration and the activities, personalities and innovations of many of the Ọbas are remembered in lavish detail.[3]

The establishment of a Yoruba-related dynasty brought Benin into a wider political and cultural orbit and redirected its spatial

orientation from east to west. The east is the cardinal direction associated with the creator god, Osanobua, and with the creation of the land, which first rose out of the primordial waters in a place which today is the Igbo town of Agbor to the east of Benin. All the sites where once the Ogiso built their palaces and ancient quarters are on the eastern side of the present city. In contrast, the founder of the second dynasty came from Yorubaland, to the west of Ędo, and many of the important early Ǫbas came from western districts of the Benin kingdom. The change in spatial orientation was accompanied by a shift from a closed society to an open one: Benin became cosmopolitan and receptive to foreign ideas not only from the Yoruba but, through expansion and trade, from other neighbouring groups and eventually from Europe.

The arts and crafts associated in oral tradition with the Ogiso period are those considered the most basic for survival and closest to the core of Benin social, political and religious life. These include domestic implements, such as wooden kitchen utensils and iron tools, as well as woven raffia cloth and leather ceremonial boxes.[4] Jewellery made of brass was worn as adornment. This view of past usage can be found in the traditional song:

> Evikurure, the daughter of Ogiso,
> When she raises her hand, brass sounds *giengheren**
> When she raises her leg, brass sounds *giengheren*
> *[*giengheren* is an onomatopoeic word for jingling]

Art forms crucial to status differentiation and religious worship are attributed to Ogiso times, particularly the rectangular throne (*agba*), the ceremonial sword (*ada*) and the ancestral commemorative head (*uhunmwun-elao*). It is interesting that, in the traditions surrounding these objects, each undergoes a transformation with the arrival of the new dynasty. Oral history indicates that the political transition was not without conflict and, as we shall see, stories about these three objects clearly reflect the struggles of the kings of the new dynasty to consolidate their rule over the Ędo people.

The *agba* (fig. 12) is an elaborately carved stool which is said to have once served as the throne of the Ogiso kings. Its political importance is embedded in the language: the Ędo phrase for convening a meeting (*fiagba*) means literally to 'bring out an agba'. Possession of the *agba* was in early times the mark of legitimate authority. In his difficult struggle against representatives of the former regime, the fourth Ǫba, Ęwędo, finally wrested the stool of the Ogiso from them and thus established his authority in Benin.[5]

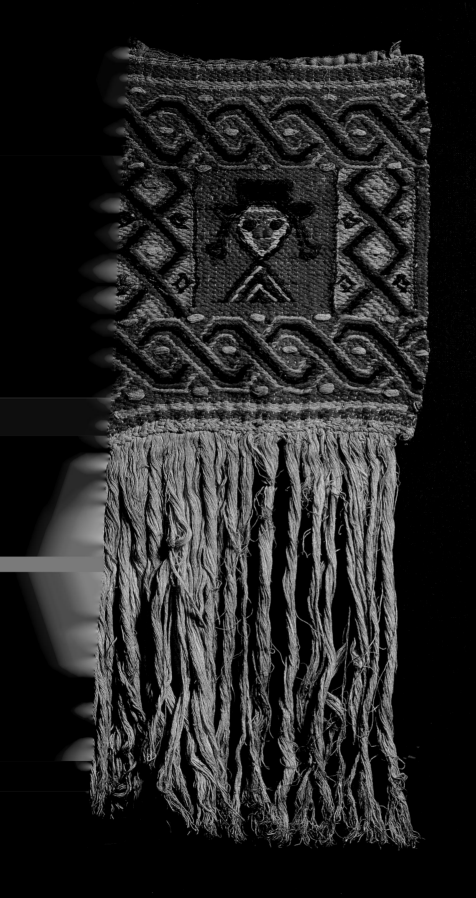

10 Brocaded cotton waist pennant (*ẹgbẹle*). The art of weaving is thought to have originated in the Ogiso period, but according to guild members, was not organised until the reign of Ọba Ọhẹn, the eighth king in the new dynasty. Struck by paralysis, the Ọba was forced to cover his legs with cloth and therefore formed a guild for its provision. One of their first creations is said to have been this type of waist pennant, worn by chiefs at ceremonies and sometimes hung above ancestral altars at the yearly Iguẹ rite. H. 30cm.

11 Terracotta commemorative head. Philip Dark has pointed out that there are nearly sixty of these heads in museums and private collections, over half of which have holes in the crown (PC1979). The late Chief Ihama of the brass-casters' guild claimed that the holes were for the insertion of ivory tusks and that the terracotta heads were used by the Ogiso rulers on their paternal ancestral altars much as the Ọbas use ivory tusks on brass heads (PC1976). (See figs 39 and 69.)

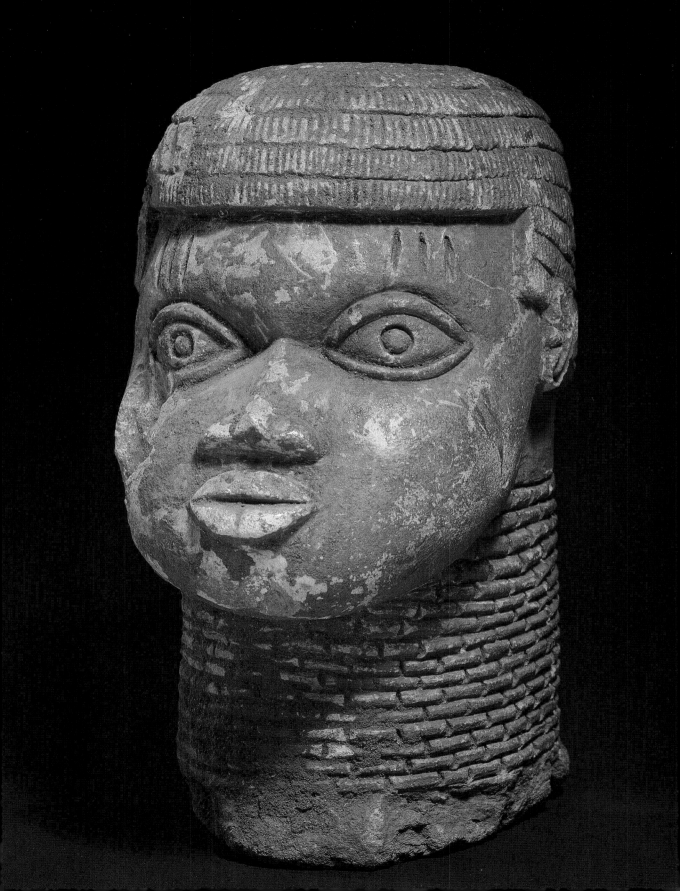

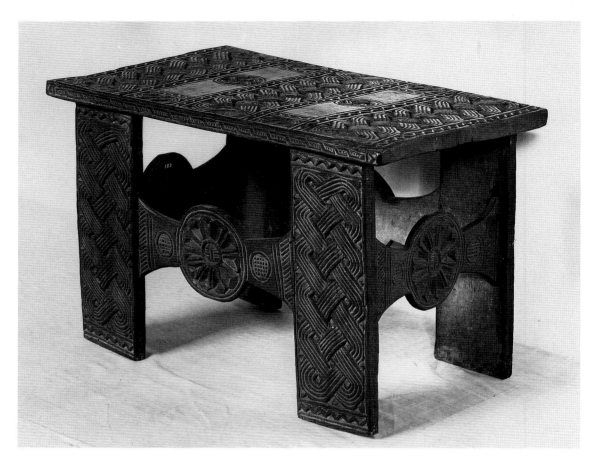

12 Wooden stool (*agba*). According to some traditions, with the transition from the Ogiso to the Oranmiyan dynasties, the *agba* was superseded by the round throne (*ekete*) which has strong Yoruba associations. Today such a stool is used by the king for non-ceremonial purposes and by chiefs as marks of their high status. While the Ẹdo view the *agba* as one of their oldest types of stools, the rectangular form and additive construction are not common in sub-Saharan Africa and, as Roy Sieber has suggested, may be derived from a European prototype (pc1979). The guilloche pattern on the stool is the widely used *oba n'iri agbọn*, 'the rope of the world'. (Compare fig. 6.) H. 44cm.

13 OPPOSITE An iron ceremonial sword (*ada*) with a brass grip covered with coral beads. The *ada* is carried by pages (*emada*) during the public appearances of the Ọba. It symbolises his right to take human life. The Ọba delegates the *ada* to high-ranking chiefs who may have it carried alongside them in their own domains, though not in the palace. L. 89cm.

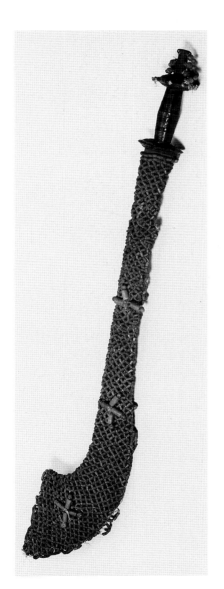

In Ogiso times the iron ceremonial sword called *ada* (fig. 13) was part of the furnishings of the ancestral altar, where it expressed the power of the ancestors to control the course of events. The Ẹdo believe that iron has the mystical power of *asẹ* to ensure that whatever proclamations are made will come to pass. In the second dynasty, the Ọbas took to making public appearances accompanied by pages carrying the *ada*, thereby incorporating an ancient Ẹdo sanction into the new royal symbolism.

Ancestral commemorative heads, *uhunmwun-elao*, have existed since earliest times as a way of honouring the deceased and beautifying ancestral shrines (see figs 65, 69). They were made of different materials, depending on the political and occupational status of the owner. Wooden ones for chiefly altars originated either in the Ogiso period, as royal traditions would have it,[6] or well into the new dynasty, according to members of the carvers' guild (see fig. 67). According to some traditions, terracotta heads – today found only in the ward of brass-casters – were formerly the most widespread commemorative sculpture, used on the royal ancestral altars of the Ogiso kings and on shrines in Idunmwun Ivbiọtọ, the quarter of the 'sons of the soil' built in Ogiso times, and in Idunmwun Ogiefa, the ward guild responsible for purifying the land after the violation of taboos (fig. 11). Breaking away from this association with ancestral soil and early rulers, the Ọbas of the second dynasty introduced the brass commemorative head as their own distinctive shrine decoration (fig. 39). The significance of brass, at least in the modern Ẹdo view, derives from its red colour and shiny surface, qualities which are considered both beautiful and threatening – a particularly appropriate symbol for the monarchy.

The question of the origin of brass-casting in Benin is intriguing and far from being resolved. Since 1897 there have been attempts by colonial officials, historians and anthropologists to collect oral traditions about this problem, but the results have been confusing because the investigators did not always ask the same questions nor did they interview the same people.[7] The version published by J. U. Egharevba, an Ẹdo historian, is the best known and most utilised by scholars. It parallels the story of the origin of the royal dynasty by asserting that the arts of casting as well as those of ruling came from Ife:

Ọba Oguọla [the fifth king] wished to introduce brass-casting into Benin so as to produce works of art similar to those sent him from Ife. He therefore sent to the Oni of Ife for a brass-smith and Iguẹgha(e) was sent to him.[8]

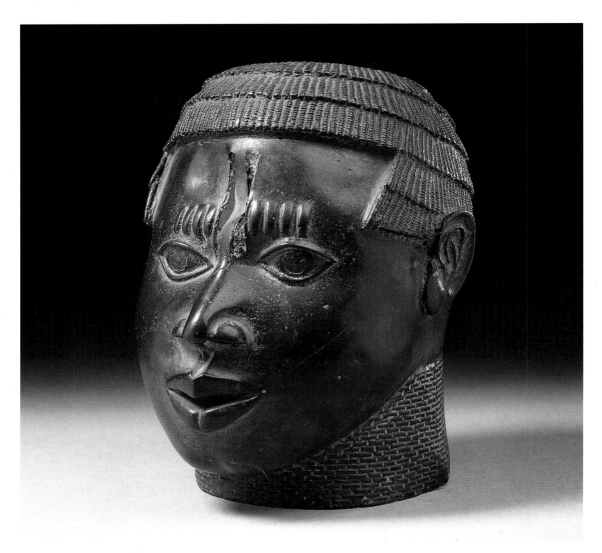

14 Brass trophy head. The casting of trophy heads may have originated a long time ago. In the Benin Museum there are two heads, one attributed to the reign of Ọba Ọzọlua (late fifteenth or early sixteenth century) and one to the reign of Ọba Akẹngbuda (late eighteenth century). In his important 1963 book *Nigerian Images*, William Fagg argued that this type of head characterised the Early Period of Benin art, and preceded in style other types of commemorative heads. However, evidence collected in Benin – and supported by Willett in his 1994 study of the composition of the alloys – indicates that these are not commemorative but rather trophy heads. According to Chief Ihama of the casters' guild, 'In the old days they used to cut off the head of [conquered] kings and bring it to the Ọba, who would send it to our guild for casting. They did not necessarily cast heads of all the captured rulers, but just the most stubborn among them. If it happened that the senior son of a rebel king was put on the throne, the Ọba would send him the cast head of his father to warn him how his father was dealt with. In the old days these heads were kept in the Shrine of the Ancestors of the Benin Nation.' (pc1976). Nevadomsky (1986) suggests instead that these trophy heads were placed on the Aro-Okuo, the shrine of war. H. 21cm.

15 One of a series of brass plaques depicting Benin warriors in battle against their enemies, who exhibit different facial markings.

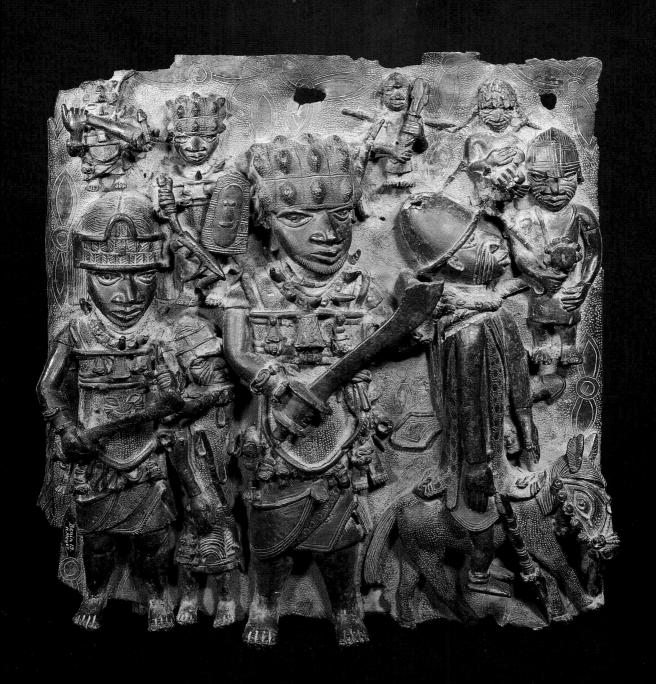

Unfortunately, it is not clear whether Egharevba's story is about the origin of the technique of casting, the introduction of specific objects or the incorporation of one family into the casters' guild. The guild of brass-smiths, like many others in Benin, is composed of several lineages that have been incorporated at different times and have various origins, some even coming from outside the kingdom. The lineage of the senior title-holder, the Inẹ, maintains a tradition (which was probably the basis for Egharevba's published one) that until the time of Ọba Oguọla, brass-workers used to come from Ife every autumn to present their work to the king. Ọba Oguọla succeeded in enticing them to stay permanently in Benin and gave their leader, Iguẹghae, the title of Inẹ.[9]

The family of the second-ranking title-holder, the Ihama, claims, in contrast, to be autochthonous. According to the late Chief Ihama, brass-smiths already existed in Ogiso times but then produced only small objects such as bracelets and bells. In the fifteenth century, Ọba Ẹwuare introduced the casting of commemorative heads and other large objects and gave his family the title of Ihama. So traditions about brass-casting would seem to reflect the incorporation of families into guilds and the awarding of titles as much as they do the introduction of a technique or of a particular artistic form.

Archaeology so far has not yielded many answers about the origin of brass-casting in Benin. Only a few pre-European sites have been excavated and it is difficult to know whether they are representative. Nevertheless, the finds are important because they date to about the thirteenth century AD and consist of bronze objects – bracelets, rings and the like. Scholars have disagreed as to whether these early objects were made by smithing and chasing or by lost-wax casting, as were later Benin pieces[10] (fig. 16). There is a gap in the Benin archaeological record until the seventeenth and eighteenth centuries, and by then the lost-wax method of casting was generally in use.[11] Thus, we do not know when casting was first employed in Benin. This technique was also used at the important artistic centres of Igbo Ukwu (ninth century) and Ife (fourteenth and fifteenth centuries) not far from Benin; however, the exact relationship between these three traditions is still to be determined.

Although these early pieces are made of bronze (an alloy mainly of copper and tin), most Benin sculpture so far tested has proven to be brass (copper and zinc).[12] Tin is found locally in Nigeria but copper is not, and so to make these early bronzes Benin must have been tied into a trading network before European contact. Archaeological discoveries of cowrie shells and glass beads dating from the

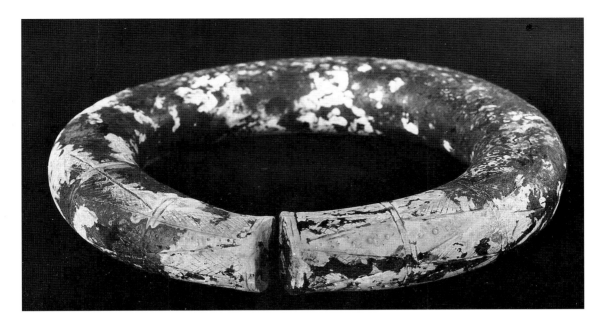

16 Thirteenth-century bronze bracelet excavated by Graham Connah (1975) from a mass burial ground along with numerous similar bronze objects.

same time are further evidence for trade links because this kind of cowrie shell comes from the east coast of Africa, while the beads could have come from Ife, a centre of glass-working by the early fourteenth century, or some yet undiscovered source. Thus, by about the thirteenth or fourteenth centuries Benin had entered commercial networks to acquire metal, shells and beads for economic, cosmetic, artistic or ritual uses.[13]

The Age of the Warrior Kings: the Fifteenth and Sixteenth Centuries

The fifteenth and sixteenth centuries are crucial in Benin history. It was an age of conquest and artistic flowering. Many of the brass sculptural forms so characteristic of Benin art – commemorative, trophy and queen mother heads as well as plaques and stools – are either mentioned for the first time in oral traditions about this period or are specifically attributed to Ọbas who ruled then. This clustering of traditions makes it difficult not to see these two hundred years as critical to the development of art in Benin.

The fifteenth and sixteenth centuries were the period of the warrior kings: Ọbas Ẹwuare, Ọzọlua, Ẹsigie, Orhogbua and Ehẹngbuda. It was a time of consolidation, development and expansion of the kingdom. Benin oral history is full of tales of warfare and conquest, and the art is in part a reflection of the times (figs 14, 15). At its height, the kingdom extended in the west to Lagos and

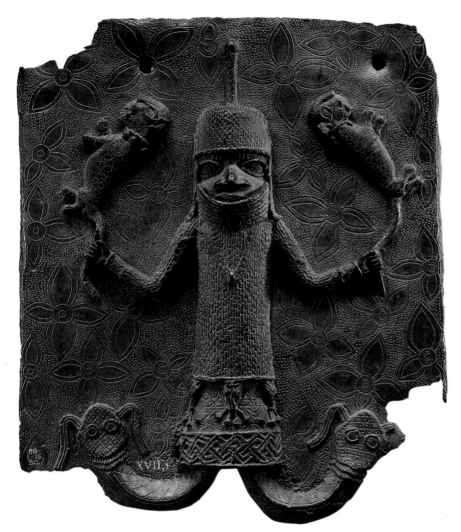

17 Brass plaque representing an Ọba sacrificing leopards, a ritual act performed at his coronation and at Iguẹ, the annual rites dedicated to strengthening his mystical powers. In oral traditions, the leopard is associated with the period before Ẹwuare assumed the throne. During his wanderings in exile, he slept one night under a tree and in the morning found a leopard above him on the branch. Ẹwuare took the leopard as a sign of future fortune and vowed that if he ever became king he would sacrifice a leopard every year to his Head, the locus of his luck and power. Representation of the king with mudfish legs accomplishes his symbolic identification with Olokun, god of the great waters and source of all earthly wealth. Gallagher (1983) suggests that the mudfish is *Malapterurus electricus*, and, in the same volume, Blackmun explains that the king's legs are depicted in this form 'to reinforce the ancient belief that the Ọba's feet are so highly charged with life force that they must never touch the wet ground for fear of damaging the land.'
H. 39.5cm.

18 Coral bead crown. The beads of the Ọba are the emblem and essence of his office. He alone can wear a complete outfit of coral beads. In his wardrobe are many different style of dress and crowns; indeed, one of his praise names is 'Child of the beaded crown; child of the beaded gown.'
H. 15cm.

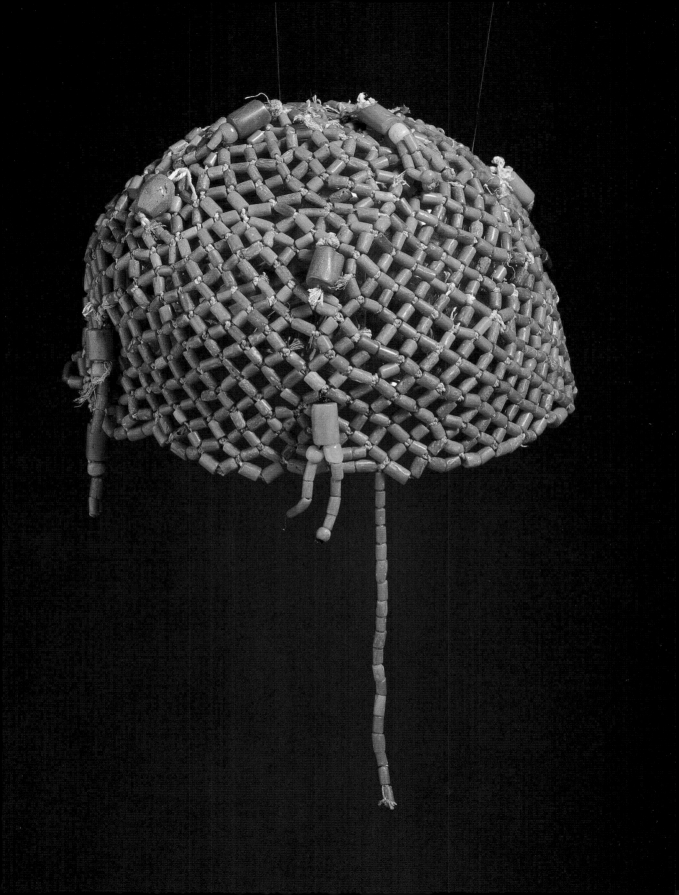

19 Brass pendant worn by the Atah of Idah, ruler of the Igala. According to Boston (1962), traditions within the Igala royal family claim a Benin origin for the dynasty. The Atah has several objects of clearly Benin origin to sanction his kingship: this 'bronze' pendant (one of two), a 'bronze' cylindrical throne and an ornamental iron staff. Head-shaped pendants of apparently Benin origin are found over a large area of southern Nigeria, indicating something of the Benin sphere of influence. H. 29cm.

beyond to Whydah (former Dahomey), in the north-east to Ekiti and Owo, in the north-west throughout most of the Ishan area, and to the east up to the Niger River. However, 'the frontiers were continually expanding and contracting as new conquests were made and as vassals on the borders rebelled and were reconquered'.[14] During this period Benin notions of kingship – and the aesthetic ideas and objects associated with it – were spread over a large area as a result of practices such as sending royal brothers to rule over tributary areas, holding sons of conquered chiefs as hostages or trainees within Benin City and sponsoring candidates for the thrones of groups under its sway. Specific objects, such as *ada* and brass pendant masks (fig. 19), were sent to vassal lords as emblems of their authority. Even in areas outside direct Benin control, like the Niger Delta, the reputation of the Oba was such that leadership disputes were brought to him for arbitration and those who proved successful brought home Benin regalia.[15] It is possible, then, to characterise the art of this period as an effort to 'affirm [Edo] national identity in time and space, to communicate the validity of their state and to justify its policies, and to foment a sense of mission that would lend impetus to military conquest'.[16]

The first of the warrior kings, Oba Ewuare, who probably reigned in the mid-fifteenth century, looms large in Benin oral history. Even more than Oranmiyan and the early rulers of the dynasty, Oba Ewuare set the patterns of Benin kingship. Under him Benin was transformed on every level, from its physical appearance to its religious and political organisation. Oba Ewuare's 'revolution' is expressed symbolically – whether or not it ever occurred in actuality – by his incineration of Benin City. Out of its ashes he constructed a new city and a new polity. Houses that were once built of poles or palm ribs padded with mud, like those of the south-eastern neighbours of Benin, were now constructed of courses of packed mud in a similar way to Yoruba houses. The palace, which had lacked a permanent site in previous reigns, was rebuilt on a large scale in the place where it has remained ever since. Under Oba Ewuare the palace truly became the spiritual and political hub of the nation.

Oba Ewuare is credited with laying out the basic plan of the city (see Map 2), with its roads radiating out of the centre as in Yoruba towns.[17] It is also supposed to have been Oba Ewuare who divided the city into two parts – the Oba's sector (Ogbe) and the town (Ore n'Okhua) – and organised the population of the capital into wards, each characterised by the particular craft or ritual service which it

owed the king. Ọba Ẹwuare is said to have constructed the inner wall or defensive earthwork of the city. Under each of its nine gates he placed magical charms to protect the kingdom from its enemies.

The restructuring of the city was paralleled by governmental reorganisation. According to traditions, Ọba Ẹwuare established the three associations of Palace Chiefs, initiated lineal as opposed to collateral inheritance of the kingship, and made a number of other important innovations associated with a period of 'political centralisation and administrative differentiation'.[18] At the same time, the Benin Empire began its period of expansion. Ọba Ẹwuare organised a 'war machine', which became an integral and permanent part of the state and thus extended the power of Benin far beyond its former borders.[19]

Similarly, Ọba Ẹwuare is supposed to have established an annual cycle of royal ceremonies to protect and purify the nation. Most important of these were Ugie Erha Ọba, in which the royal ancestors were honoured, and Iguẹ, which was supposed to strengthen the mystical powers of the king. The elegant and elaborate ceremonial costumes worn by the king and chiefs also originated in Ọba Ẹwuare's time, in particular the coral bead regalia so important to kingship (fig. 18).

In one story, Ọba Ẹwuare went down to the river at Ughọtọn village and stole the beads belonging to Olokun, god of the waters; he brought them back to Benin and thereby established the palace of the Ọba, king of the dry land, as the earthly counterpart of the palace of Olokun, king of the waters. Thus, in Benin traditions, nearly every aspect of royal regalia and royal ritual is traced back to Ọba Ẹwuare, indicating that much of what is 'divine' in the divine kingship may have started at that time (fig. 17).

The arts, particularly brass-casting, also flourished during his reign. One popular story about Ọba Ẹwuare relates that when he had grown old he asked the members of both the casters' and carvers' guilds to make an image of him. The casters depicted him as he appeared at the prime of life, but the carvers showed him as he was at the time of the commission, in his old age. Ọba Ẹwuare was furious with the carvers and demoted them, proclaiming that they would never again be as important as the brass-workers. It is possible that this story is indirect evidence for the introduction of royal brass commemorative heads, as the late Chief Ihama of the casters' guild felt it to be. It certainly seems to reflect a change in guild hierarchy, for the carvers, organised during Ogiso times, should automatically rank higher than the casters, who were organised much later. The 'explanation' of their status reversal

could reflect changes in the cultural evaluation of artistic materials.

The sixteenth-century kings continued the patterns of conquest set by Ọba Ẹwuare, but their path was not always smooth. The reign of Ọba Ẹsigie, the grandson of Ọba Ẹwuare and the fifteenth king, is marked in Benin traditions by two great conflicts, one internal and the other external. When Ọba Ọzọlua, the successor of Ọba Ẹwuare, died, a struggle for power ensued between his two sons, Ẹsigie in Benin City and Arhuaran in the town of Udo about twenty miles to the north-west. Udo at that time was an important centre, probably as large and powerful as Benin City, and its ruler apparently wished to make it the capital of the kingdom. According to Chief Ihama, during the conflict brass-casters were taken by force to Udo and worked there until Ẹsigie won the war (pc1976). In another account Udo is described as the temporary residence of brass-casters during their annual visit from Ife, before Oguọla, the fifth Ọba, succeeded in enticing them to reside in Benin City. While these two traditions refer to different times and circumstances, both suggest a brief period of casting at Udo (fig. 20).

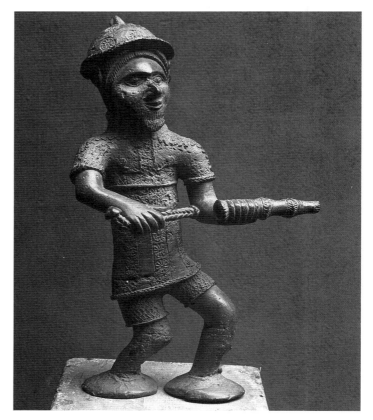

20 Brass figure of a Portuguese soldier. This figure, shown by William Fagg (1963) to be in a distinctly provincial style, was found, together with two similar ones, in Udo Village. According to Murray's catalogue of the Benin Museum collection, at the time of the British Expedition there were eight brasses in the possession of the highest-ranking chief of Udo. H. 34.5cm.

21 Brass plaque probably representing Ọba Ẹsigie on his triumphant return from the Igala war. As he set out to battle, the prophetic bird *ahianmwẹn ọrọ* cried out that disaster lay ahead. Ẹsigie had the bird killed and proclaimed that 'whoever wishes to succeed in life should not heed the bird of prophecy'. Upon his return he had the brass-casters make an image of the bird in the form of a staff (see fig. 82). H. 43cm.

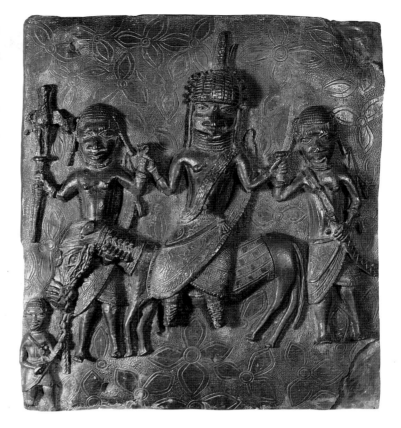

Ọba Ẹsigie's second major struggle was against the Igala people in the north, who are said to have attacked the kingdom, threatening its very existence. Benin oral traditions abound with stories about this war which Benin finally won, driving the Igala soldiers across the Niger River and apparently establishing their king, the Atah, as a vassal of Benin (figs 21, 22). It is possible that the conflict with the Igala was over control of the Niger waterway.[20]

The fifteenth and sixteenth centuries are significant in Benin history because they mark the first direct contact with the European world. In the second half of the fifteenth century, Portuguese navigators began to explore the West African coast and appear to have reached Benin some time between 1472 and 1486. They found a highly developed kingdom in the process of territorial conquest, with which they were able to establish diplomatic and trade relations. According to Benin traditions, the monarch ruling at that time was either Ọba Ọzọlua or, more probably, Ọba Ẹsigie. The Portuguese hoped to introduce Christianity, particularly after they

22 Commemorative head for the altar of a Queen Mother. Idia, the mother of Ọba Ẹsigie, was a powerful woman whose military and occult skills played an important role in her son's successes, particularly the Igala war. In her honour Ẹsigie is said to have instituted the title of Queen Mother (Iyọba) and established the tradition of casting this type of brass head. The long beaded cap covers the distinguishing hair style of the Queen Mother, called 'chicken's beak'. Heads of this type were placed in altars in the palace and at the Queen Mother's residence in Uselu. H. 51cm.

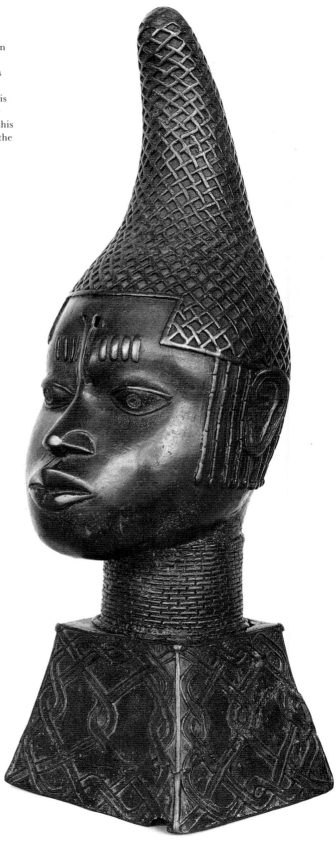

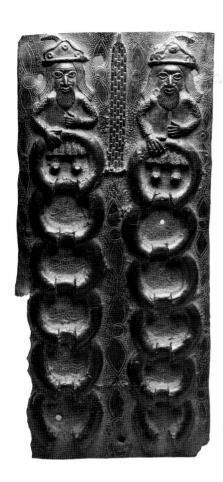

23 Brass plaque of two Portuguese above rows of manillas, an early form of trade currency. H. 45.7cm.

received reports that the Benin sovereignty was sanctioned by a ruler called the Ogane, living far in the interior, who sent the Oba a bronze cross, amongst other objects, which confirmed his authority. Missionaries were despatched, but in the end Portuguese hopes for converts in Benin were not fulfilled.[21]

The arrival of the Portuguese coincided with a period of great political and artistic development, as we have seen, and their coming undoubtedly suited monarchic purposes. Portuguese mercenaries provided Benin with support against its enemies, while traders supplied the important luxury items Benin so desired: coral beads and cloth for ceremonial attire and great quantities of brass manillas which could be melted down for casting. One of the palace associations, Iwebo, was appointed to conduct affairs with the Portuguese, and to this day its members speak a secret language that some of them claim is derived from Portuguese.

In return for these goods, Benin provided the Portuguese with pepper, cloth, ivory and slaves. By the last quarter of the sixteenth century, if not earlier, Benin craftsmen were busy carving ivory objects ranging from spoons with figurative handles, sold at modest prices to sailors, to the more elaborate salt cellars and hunting horns, destined apparently for the Portuguese nobility (fig. 24). The Edo were not alone in this enterprise, for other groups along the African coast, in present-day Sierra Leone/Guinea Bissau, western Nigeria, and Zaire, were similarly commissioned. The Benin Portuguese ivories are a blending of status imagery from two cultures: from Europe, there are Portuguese coats of arms, armillary spheres and scenes of the nobility hunting; from Benin, guild designs reserved for royalty, and views of nobles on horseback, accompanied by retainers and equipped with swords, elaborate costumes, feathers and other Benin marks of rank and wealth.[22]

The Portuguese also had an impact on the royal arts of Benin. Coming from far across the sea, bringing with them wealth and luxury items, the Portuguese travellers were readily assimilated into (or perhaps generated) the complex of ideas and motifs associated with the god Olokun, ruler of the seas and provider of earthly wealth. Cast or carved images of the Portuguese sailors in sixteenth-century attire appear in a wide variety of contexts – on bracelets, plaques, bells, pendants, masks, tusks, and so on. Generally they are accompanied by the denizens of Olokun's world (mudfish, crocodiles, pythons and the like) and a multitude of chiefs, retainers and royal figures of the Benin court. The image of the Portuguese, thus, became an integral part of a visual vocabulary of power and wealth (figs 23, 26).

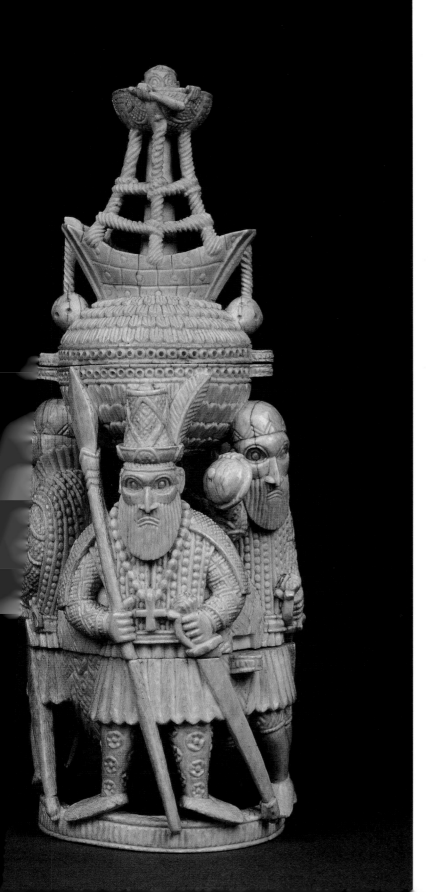

24 Afro-Portuguese ivory salt cellar. This tripartite salt cellar depicts four Portuguese along the base and a fifth in a boat holding a telescope atop the lid. Curnow (1983) points out that the Portuguese are wearing a costume that dates to the 1520s–40s and their beards and short capes are based on Spanish fashions popularised by the Emperor Charles v. Although their form is of European derivation the style is distinctly Ẹdo. H. 30.5cm.

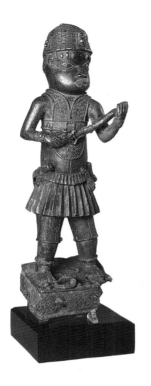

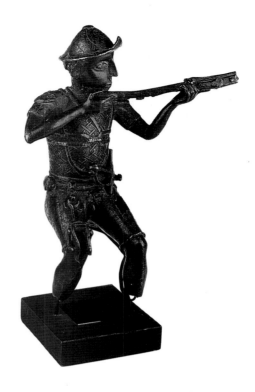

25 Brass figure of a Benin court official holding a musket. This figure is probably a member of the Iwoki guild, a group concerned with unusual celestial phenomena like eclipses and comets. According to guild traditions collected by Bradbury (1959, 1973), their founders were two Portuguese, Uti and Ava, who arrived during the reign of Ọba Ẹsigie. At the annual Irọn ceremony the Iwoki stand on either side of the king holding guns as his defenders. Irọn commemorates the triumph of Ọba Ẹsigie over the rebellious Seven Uzama, a high-ranking order of chiefs. H. 44.5cm.

26 Brass figure of a Portuguese archer holding a crossbow. According to Maria Elena Mendes Pinto (1983), he is wearing a morion, recognisable by its upturned lid. The sword and rack for bending the crossbow resemble types made in the first half of the sixteenth century. H. 30.5cm.

This can be seen most vividly in one art form, the brass plaque. In oral traditions, the earliest reference to the making of plaques is in the reign of Ọbas Ẹsigie and his son Orhogbua. A British official in 1897 was told that a caster named Ahammangiwa (a name of unclear origin) accompanied the Portuguese to Benin, making 'brasswork and plaques' first for Ẹsigie and later for his son Orhogbua, to commemorate the successful war against the Igbo.[23] It is not clear whether this is a story about the origin of brasswork generally or of plaques specifically – or whether it is a story of origin at all. Whatever the case, it does suggest that plaque production was flourishing in the period of Portuguese contact. It is possible that the Portuguese introduced the notion of plaque making, perhaps, as one scholar proposes, by showing Benin casters small books of pictures. Indeed, some of the background designs on the plaques, such as the quatrefoil or rosette, may have European or even Islamic origins.[24]

There are over nine hundred plaques known, and they provide a testimony to court life at that time. Although they are generally considered to be 'a sort of pictorial record of events in Benin history, an aid to memorising oral traditions',[25] in fact very few of them now appear to us to convey narratives. Apart from the war plaques

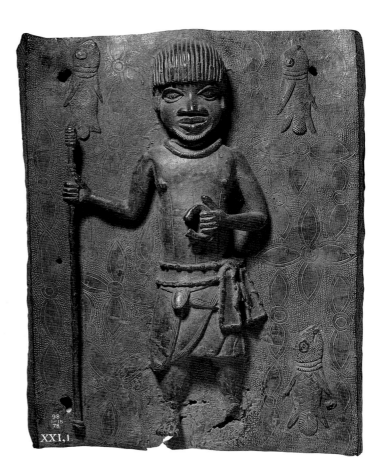

27 Brass plaque of a Benin trader, probably one appointed to deal with Europeans. He carries a staff of office in his right hand and a manilla in his left. H. 46cm.

(fig. 15) or the commemoration of Ọba Ẹsigie's triumph over the Igala (fig. 21), the majority represent kings, chiefs and courtiers in ritual posture. Whatever narrative content they may have had has been lost. Their ritual content, however, can be partially reconstructed through the identification of costume (figs 77, 78, 92, 93).

The plaques also appear to contain cosmological references intimately related to the Portuguese period. The background design on the majority of plaques is a quatrefoil, while on a minority there is a circled cross. Both of these patterns are associated now (and may well have been in the past) with Olokun, god of the waters. The quatrefoil represents river leaves,[26] which are used by Olokun priestesses in curing rites, and the circled cross is one form of the *aghadaghada* design drawn in chalk at the centre of all Olokun shrine courtyards. Both the leaf and the circled cross are quadrivial, a basic cosmological form in Benin thought. Called *ẹdẹ enenẹ*, the cruciform represents simultaneously the four cardinal direc-

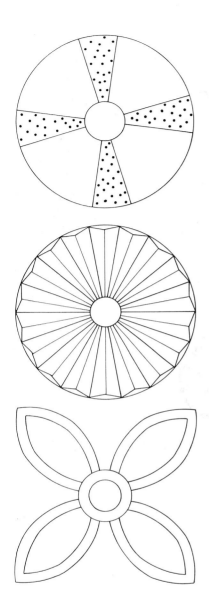

OLOKUN DESIGNS FOUND ON PLAQUES. The one on top is called *aghadaghada* (a play on the word *ada* meaning 'crossroads'); in the middle is *owẹn iba ẹdẹ ku*, 'the sun never misses a day'; on the bottom is *ebe-amẹn*, 'river leaves'.

tions, the four days of the Ẹdo week, and the unfolding of the day – morning, afternoon, evening and night – at the time of creation. In the corners of many plaques are designs similarly relating to Olokun: Portuguese heads, crocodiles, fish and rosettes, which represent the sun, associated with Olokun through its daily descent into the sea. The appearance of so much Olokun imagery as background in plaques depicting court ritual and court life is a perfect commentary on the period of Ẹsigie's reign, when the powers of the sea worked behind the Ọba to strengthen and expand the kingdom.

Crisis and Renewal: the Seventeenth and Eighteenth Centuries

The Portuguese impact was brief, for they were soon surpassed in trade by the Dutch, French, and English. Visitors throughout the seventeenth and early eighteenth centuries have provided us with a vivid picture of the size and complexity of Benin City and of the customs, ceremonies, costumes and art forms associated with Benin life both at court and at large. Indeed, we find in the diary entry 'The first voyage to Africa, as far as Rio Benin' by Andreas Josua Ulsheimer, a German traveller who visited the Guinea Coast in 1603–4, the earliest known description of a domestic ancestral altar:

They mourn their dead for three months, twice every day; and in the same house where the deceased father lies, the son who succeeds him has set up the heads of all the animals which his father has slaughtered and eaten – cows, goats, pigs, dogs, sheep, etc. – all around; it looks just like an altar. They also have large elephant tusks standing there, and all around they put as many wooden heads as the number of enemies whom the deceased father killed and slew in war during his lifetime.[27]

Dutch descriptions of the royal palace and its art works are of particular interest because this important edifice was destroyed by fire in 1897 and thus we can know about it only indirectly through these accounts and artistic depictions. In the writings of Olfert Dapper, who used early seventeenth-century Dutch reports as his sources, we find the earliest known European depiction (fig. 28) and written description of the palace:

The king's court is square, and stands at the right hand side when entering the town by the gate of Gotton [Ughọtọn], and is certainly as large as the town of Haarlem, and entirely surrounded by a special wall, like that which encircles the town. It is divided into many magnificent palaces, houses, and apartments of the courtiers, and comprises beautiful and long square galleries, about as large as the Exchange at Amsterdam, but one larger than another, resting on wooden pillars, from top to bottom covered with cast copper, on which are

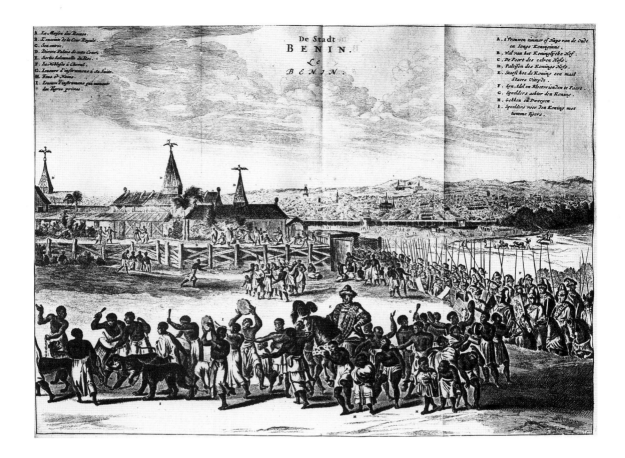

engraved the pictures of their war exploits and battles, and are kept very clean. Most palaces and the houses of the king are covered with palm leaves instead of square pieces of wood, and every roof is decorated with a small turret ending in a point, on which birds are standing, birds cast in copper with outspread wings, cleverly made after living models.[28]

Some sixty years later, a Dutch visitor, David van Nyandael, saw the same complex of apartments and galleries. His is the first description of a royal ancestral altar, of much the same form as we know today, and while he does not mention either the 'copper' birds or plaques, he does point out for the first time the cast snakes that ran along the turrets:

On top of the last [gate] is a wooden turret, like a chimney, about sixty or seventy foot height. A large copper snake is attached to its top, its head dangling downwards. This snake is so neatly cast with all its curves and everything that I can say that this is the finest thing I have seen in Benin . . . [In another gallery] one sees behind a white carpet eleven human heads cast in copper; upon each of these is an elephant's tooth, these being some of the King's gods.[29]

28 A seventeenth-century engraving from Olfert Dapper's 1668 publication based on Dutch visitors' accounts. Although this engraving was probably made in Europe from verbal descriptions, there are nevertheless correspondences with what we know of Benin architecture. The turrets are described by other visitors and are depicted in Benin representations of the palace (fig. 30). According to Dapper, 'The King shews himself only once a year to his people, going out of his court on horseback, beautifully attired with all sorts of royal ornaments, and accompanied by three or four hundred noblemen on horseback and on foot, and a great number of musicians before and behind him, playing merry tunes on all sorts of instruments, as is shown in the preceding picture of Benin City. Then he does not ride far from the court, but soon returns thither after a little tour. The king causes some tame leopards that he keeps for his pleasure to be led about in chains; he also shows many dwarfs and deaf people, whom he likes to keep at court'.

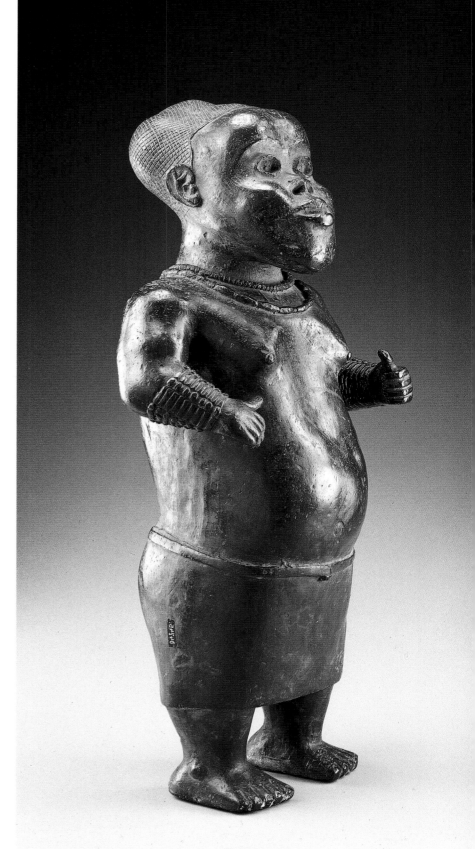

29 A brass figure of a dwarf, a member of the Ọba's entourage as described by Dapper (fig. 28).
H. 59.5cm.

30 A brass plaque showing a palace entrance with a turret. The body of the bird has been broken off but we know from similar artistic depictions that it had outstretched wings and a curved beak (see figs 21, 82). It may represent the bird of prophesy, or another bird of similar powers, for its role on the palace roof is said today to have been to warn of impending danger. The pillars supporting the turret have representations of Portuguese heads, which may be the plaques reported by Dapper or the carved wooden pillars seen by van Nyandael. H. 52cm.

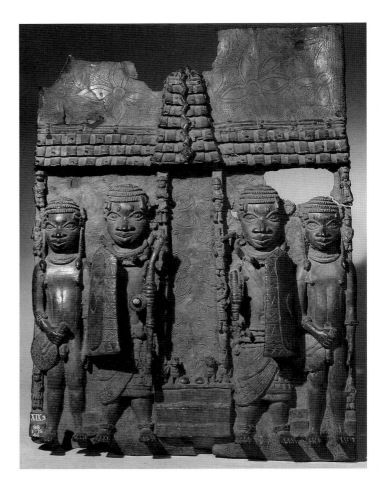

31 Brass snake head. Representations of snakes on the palace were seen by visitors from the eighteenth century onward, and a number of heads and some segments remain. According to Bradbury (1959) this snake is called ọmwansọmwan, 'one man surpasses another' (that is, all men are not equal). H. 41.4cm.

We cannot know if the differences between the accounts by Dapper and van Nyandael are due to omissions in reporting or changes in artistic use in the last years of the seventeenth century. It has been suggested, however, that the absence of reference to the brass plaques in the latter's account indicates that they were no longer being made by 1702.[30]

In looking at the history of Benin in the seventeenth century we find a curious contrast between an abundance of Dutch and other written descriptions and a paucity of local oral traditions. While the exploits of the fifteenth- and sixteenth-century warrior kings are related in great detail, little is recounted of their successors, approximately nine kings, starting with the son of the last great warrior Ọba, Ehẹngbuda (who probably reigned in the late sixteenth century), and ending with the ascension of Ọba Akẹnzua I in about 1715. Similarly, there are no art historical traditions related to this period; no objects are said to have been introduced by specific Ọbas and there are no tales containing reference to the use of artistic forms. The situation changes dramatically when we come to the eighteenth-century Ọba Akẹnzua I and his son Eresọyẹn.[31] Here the numerous traditions emphasise the great peace and artistic flowering of the first half of the eighteenth century. It is possible to comprehend this curious silence and the sudden flourishing of the arts that followed – and even the specific art forms that emerged – when we understand something of the background of seventeenth-century Benin.

The seventeenth century was a period of great dynastic turmoil. After the death of Ọba Ehẹngbuda, the last warrior king, his son Ohuan ascended the throne. 'Ohuan did not reign for long before he died and because he had no children he did not hand down royal tradition to his successor.'[32] Thus with his death, possibly around 1630, the throne was thrown open to scattered members of the royal family, who were not in the direct line of descent. Different factions struggled for the kingship and, in the process, weakened it seriously. European visitors in 1696 found Benin embroiled in a civil war which had been going on for several years. Apparently the reigning Ọba, Ẹwuakpẹ, was able to reach an understanding with the rebellious chiefs and as a result reinstated the direct line of descent. But this did not end the war (which is attested by European records well into the 1730s) and Ọba Ẹwuakpẹ's successors, Akẹnzua I and Eresọyẹn, had to search for ways to subdue rebellious chiefs and restore the power and legitimacy of the monarchy. The art forms associated with these Ọbas are a testimony to their efforts and ultimate success.

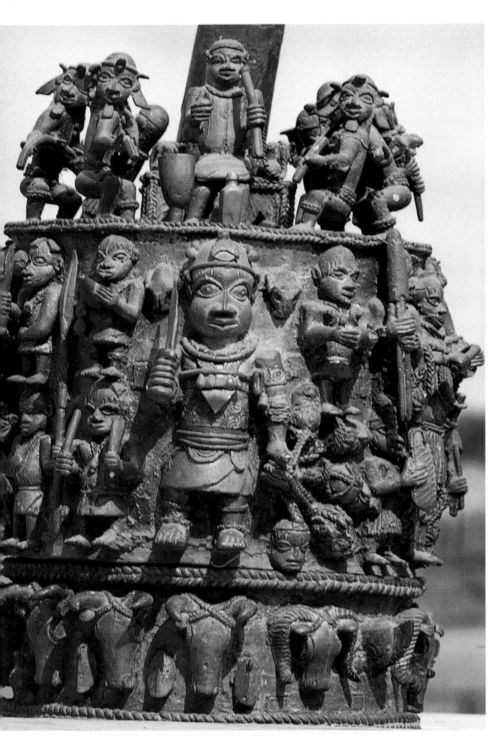

32 Brass shrine of the Hand (*ikẹgobọ*) belonging to Chief Ezọmọ. Bradbury (1973) says that within the Ezọmọ family, this *ikẹgobọ* is said to have been cast for Ehenua, the Ezọmọ who aided Ọba Akẹnzua I in conquering Iyasẹ n'Odẹ; however, he and Fagg feel that on stylistic grounds the main body of the casting, but probably not the base, may be from a later date. The iconography of the piece refers to the conflict. On the top is Akẹnzua I 'making offerings to his ancestors of the success of his campaign, or giving thanks for victory'. The animals he has sacrificed form the frieze around the base. The central figure on the cylinder is Ezọmọ Ehenua, surrounded by his warriors and attendants. H. 40.5cm.

33 Brass head. The symbolism of the creatures represented refers to the mystical and magical aspects of kingship so emphasised by the eighteenth-century Ọbas. The birds and snakes are attributes of Osun, the power inherent in leaves and herbs found in the forest. The birds are similar to those depicted on the top of the palace and have the same prophetic and protective powers. Snakes are the warriors of Osun. Their representation issuing from nostrils refers to the belief that those who are magically powerful vomit out snakes when setting out to destroy their enemies. The celts, or 'thunder-stones', are associated with Ogiuwu, bringer of death, who hurls them on his enemies from the sky. H. 27cm.

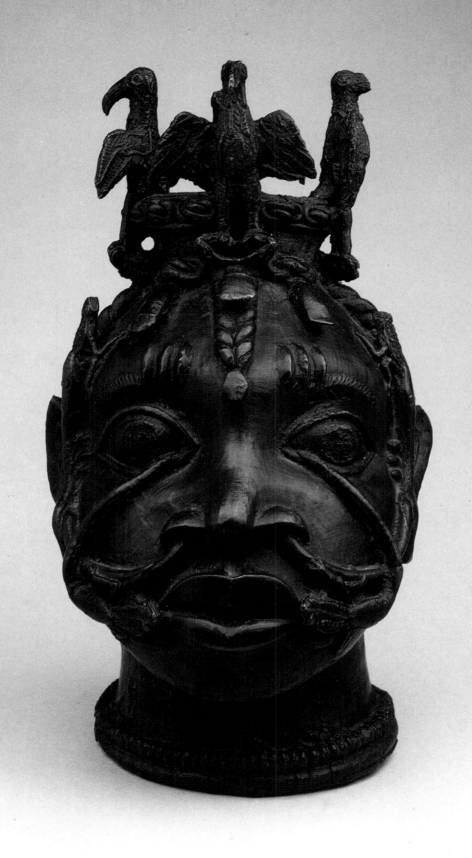

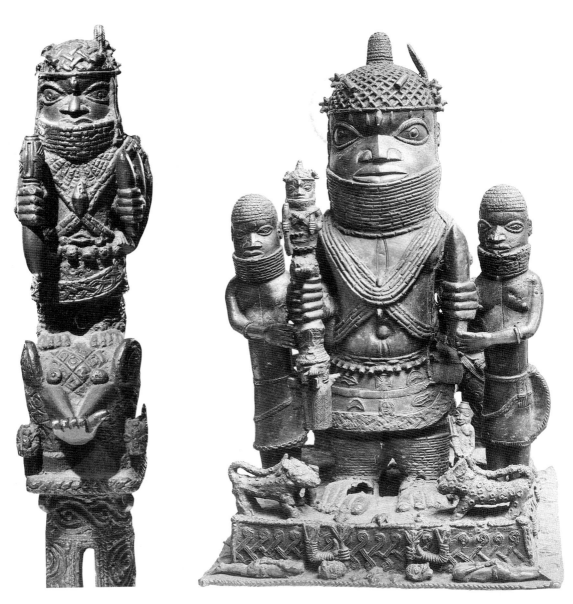

34 Top of a royal brass staff. The figure is identified in Benin as Ọba Akẹnzua I. He stands atop an elephant, which represents a chief. There are folktales recounting the rivalry between the elephant and the leopard, representing kingship. In particular the elephant is associated with Iyasẹ n'Odẹ because of his magical capacity to transform himself into one in order to vanquish enemies. This staff, showing Akẹnzua standing on an elephant, is thus a victory proclamation. H. 162cm.

35 Ancestral altar tableau (aseberia) depicting Oba Akenzua I holding the staff shown in fig. 34, as Vogel (1978) has pointed out. H. 63cm.

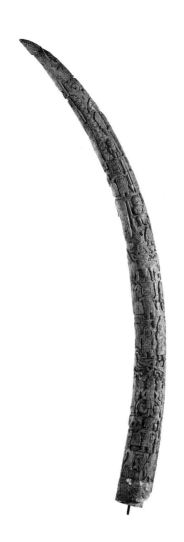

36 Carved ivory tusk. Although tusks were seen on ancestral altars by seventeenth century European visitors, carved ones were not noted until the late eighteenth century. These elaborately-carved tusks were made not only for the king but, as Barbara Blackmun (1994) has demonstrated, for the Queen Mother and important chiefs as well. According to Blackmun, this tusk is among the earliest of the decorated ones, probably made in the mid-eighteenth century for Ọba Akẹngbuda (pc1994). H. 198cm.

Oral traditions indicate that both Ọbas Akẹnzua I and Eresọyẹn sought to strengthen the kingship through a combination of political, economic and ritual means. During the preceding century, independent chiefs had succeeded in establishing private power bases and had apparently even selected kings from among their ranks.[33] At the turn of the century, a particularly strong Iyasẹ (head of the Town Chiefs and one of two supreme military commanders) was involved in a rebellion against Ọba Ẹwuakpẹ and, after the latter's death, supported a rival brother of Akẹnzua I. This rebel chief, Iyasẹ n'Odẹ, appears in Benin oral literature as a threatening foe and a magician so powerful that he was able to transform himself into an elephant. His legendary association with elephants is particularly apt since Iyasẹ n'Odẹ's power base was centred on the village of Ehọ directly on the ivory trade route with the Ishan area to the north. In fact, it is quite possible that the struggle between Iyasẹ n'Odẹ and the Ọba was one for control of the lucrative ivory trade that began at the end of the seventeenth century. With the aid of the other major military commander, the Ezọmọ, Ọba Akẹnzua I at last defeated the Iyasẹ and then went on to establish firmly the rule of primogeniture, thus ensuring stability in the royal succession. Celebration of this victory over the Iyasẹ and of the restoration of the monarchy is the theme of the elaborate brass staff of office attributed by tradition to Ọba Akẹnzua I (fig. 34).

Increased trade with the Dutch – whether it was a result or a cause of Ọba Akẹnzua's strengthened position – ushered in an era of great prosperity. Ivory was a particularly important export, as Dutch trade records indicate. On the Benin side there was a similar emphasis on luxury goods. Cowries, the traditional currency, were imported in such great quantities that they literally covered the walls of the rich. Ọba Eresọyẹn is said to have constructed a 'house of money' and this apparently was emulated, perhaps in a modified form, by the Ezọmọ, for when the French trader Landolphe visited Benin in 1787, he met the then Ezọmọ in 'a large and beautiful room elegantly embedded with small Indian shells . . . which are called cauris'.[34] Traces of this decorative practice can still be seen in Benin today (fig. 4). In addition to cowries, a variety of textiles including damask, French silk and linen, and a vast number of copper and brass 'neptunes' or pans were also imported.[35] Some of the pans were undoubtedly melted down to cast the numerous brass objects said to date from that time. The emphasis on the commercial export of ivory was paralleled by an internal artistic focus. While tusks had been placed on ancestral altars as far back as

the early seventeenth century, recent research indicates that their use proliferated in the early eighteenth century, and by the 1780s huge elaborately-carved tusks were found on ancestral altars for past Ọbas, Queen Mothers, and high-ranking chiefs. Ivory armlets, staffs and containers were created in abundance.[36]

It should come as no surprise that one of the art forms *par excellence* of the eighteenth century was the brass *ikẹgobọ*, shrine of the Hand. The shrine of the Hand is the ultimate self-congratulation of the individual who has achieved great material success. Two elaborate brass *ikẹgobọ* are attributed to this time, one of which, now in the British Museum, was undoubtedly made for the Ọba (fig. 1), while the other belonged, appropriately, to the Ezọmọ, his loyal and powerful chief (fig. 32).

Restoration of the kingship nevertheless brought fundamental changes in its character. 'The revival could not carry the monarch and government back to the forms of the sixteenth century. Akẹnzua and his successors confined themselves within the palace . . . and maintained their authority . . . by an increasing emphasis upon their ritual function as guardians of the nation's prosperity and security'.[37]

Perhaps to a greater extent even than Ọba Akẹnzua, his son Ọba Eresọyẹn developed the ceremonial aspects of kingship. To this end he forged artistic and ritual links with earlier periods of the monarchy and with its most basic sanctions. Ọba Eresọyẹn is said to have commissioned a brass stool (figs 37a and b) in the exact form of one made for Ọba Ẹsigie by the Portuguese two hundred years earlier. There are indeed parallels between Ọbas Ẹsigie and Eresọyẹn: both overcame serious internal opposition and, thanks to a thriving trade with Europeans, ruled over a wealthy and powerful kingdom. In each reign brass-casting flourished. The emulation of Ọba Ẹsigie was clearly an appeal to a time when the kingdom was at its height and led by a successful monarch of undeniably legitimate ancestry.

Just as Ọba Ẹsigie had introduced a new palace ritual, Ugie Ọrọ, into the annual cycle, so Ọba Eresọyẹn introduced Ugie Ododua, but his purpose was not strictly commemorative. Ododua was brought in as a replacement for the annual ceremony of the Ọvia cult, honouring a village-based deity. At the Ọvia rite (as performed in villages today), masqueraders wearing red parrot-feather head-dresses impersonate their patrilineal ancestors. In contrast, at Ododua (named after the Ife king who sent Oranmiyan to Benin as ruler) the performers, wearing brass helmet masks, represent the founding members of the Oranmiyan line (figs 98, 99,

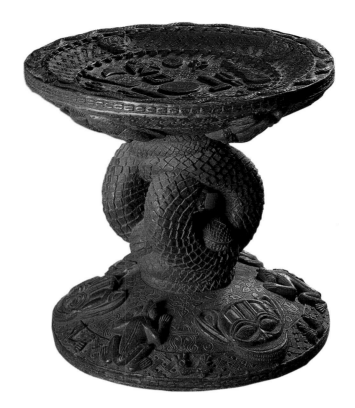

37a & b Brass stool identified today in Benin as the one commissioned by Ọba Eresọyẹn. On the base are images drawn from the forest and the water (monkeys and frogs) as well as the sign of the powerful hand. On the seat, the central disc is probably a blacksmith's anvil, surrounded on either side by blacksmiths' tools and ceremonial swords. Above these symbols of civilisation are cosmic symbols (a moon, cross and sun), and below are symbols of the forest (a monkey's head and two elephant trunks ending in hands holding magical leaves). Irwin Tunis (1981) suggests that the stool is of European manufacture. H. 39.5cm.

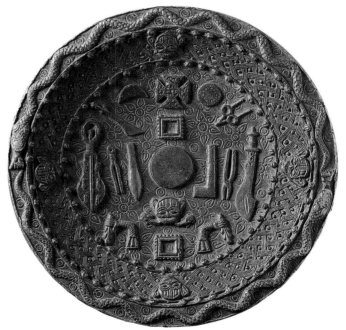

100). In replacing Ọvia with Ododua, Ọba Eresọyẹn was not only emphasising the royal lineage as opposed to more general ancestors but was appealing to the Yoruba progenitor of the Benin royal house, that is, to the ultimate legitimacy of the Oranmiyan dynasty.

Into the Colonial Orbit: The Late Eighteenth and Nineteenth Centuries

The late eighteenth- and early nineteenth-century successors of Eresọyẹn inherited a stable, prosperous and moderately expansionist kingdom. After the ivory trade with the Dutch ceased, increased commerce in slaves and palm oil with the British developed in its place. One result of this relationship with England was that Benin became an object of the Victorian interest in exploration. Two great explorers, Sir Richard Burton and Giovanni Belzoni, visited Benin, and from them and others we have

38 Sketch of the burying place of a king of Benin. The explorer Giovanni Belzoni, who visited the Benin Kingdom in 1823, appears to have written the legend to this sketch, but, as Fagg (1977) points out, there is doubt as to whether he actually did the drawing. The depiction of 'one of 25 or 30 of the 'Tombs of the Benin Kings' accords with the anonymous description in the *Royal Gold Coast Gazette*. From the sketch it is possible to identify several types of objects which until now had not been associated with ancestral altars. (See figs 40, 41).

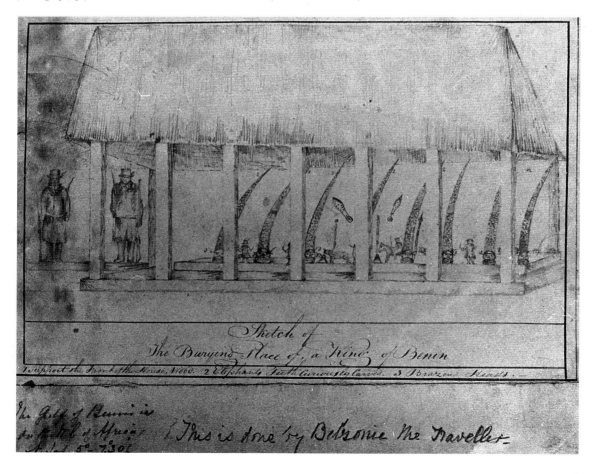

invaluable documents on its culture and art. Their accounts provide us with the last – and sometimes the only – picture of Benin royal sculpture before it was totally removed from its cultural context by the 1897 British Punitive Expedition. In addition, when compared with earlier Dutch and French reports, their descriptions provide an important historical perspective on artistic developments over several hundred years.

The royal ancestral altars have long been a focus of artistic elaboration, probably dating back to Ogiso times. The majority of the sculptural forms that most characterise Benin art were originally created to honour the royal ancestors of the Benin nation. After the death of an Oba, his successor would have an altar constructed in a large rectangular compound and would commission his carvers and casters to prepare art works to commemorate his predecessor and to enable the new Oba to communicate with him. Thus, the number of shrine compounds was normally on the increase and by the first quarter of the nineteenth century, twenty-five or thirty of them were reported by a European visitor. The number may have fluctuated with the degree of interest expressed by the reigning monarch, because at the time of the British Punitive Expedition in 1897, there were only seventeen.[38] Similarly, the types of artistic decoration may have varied from shrine to shrine and over time.

In the early eighteenth century, van Nyandael saw on one altar 'eleven men's heads cast in copper . . . and upon every one of these is an elephant's tooth'. On another he saw only carved tusks, a variant of altar decoration seen also by French and English visitors from the late eighteenth through to the late nineteenth century.[39] Yet from the early 1820s we have both a written description (by an anonymous author in the *Royal Gold Coast Gazette*) and, perhaps even more remarkable, an actual sketch of a Benin altar (fig. 38) with many other brass objects represented. According to the account:

The tombs are decorated by as many large elephant's teeth as can be set in the space; these are elegantly carved in the manner of the ancients, and the socket of the tooth is introduced into the crown of the head of a colossal brazen bust, that by its correctness of expression and regularity of features confirms our opinion of that art having been long introduced and liberally cultivated by those people. The drapery, which resembles the collar of a large toga or large gown covers part of the cheek, according to the ancient costume of Egypt, and in fact the whole is in the best style of workmanship. The other figures on these monuments are very happy, a blacksmith on an ass, and a carpenter in the act of striking with an axe, are well portrayed, and figures of animals are generally equally happy in design and execution.[40]

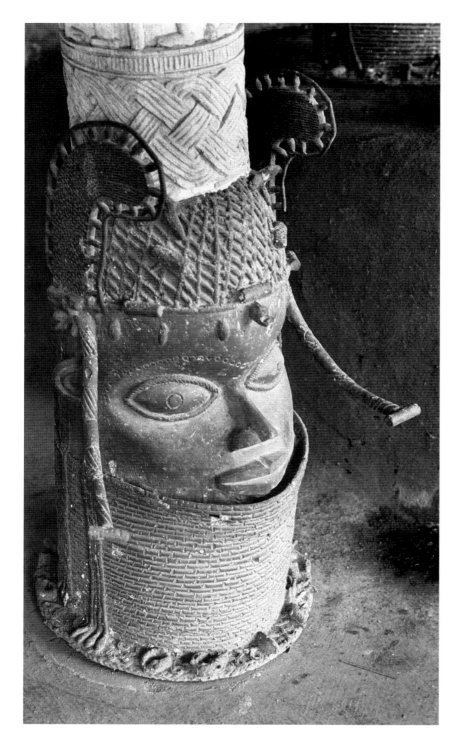

39 Brass commemorative head with tusk from the altar for Ọba Ovọnramwẹn, photographed in 1970. Continuities over 100 years can be observed.

40 This type of equestrian figure may be the 'blacksmith on an ass' referred to in the anonymous account in the *Royal Gold Coast Gazette*. The horseman may represent Oranmiyan, the founder of the second dynasty, who is said to have introduced horses into Benin, and who is also associated with the foundation of the Yoruba kingdom of Oyo, which rose to power through its mounted armies. The fact that such figures were placed on ancestral altars (fig. 38) seems to support this identification. Scholars have suggested other identifications; for example, William Fagg (1973) calls this an emissary from the north, while Joseph Nevadomsky (1986) argues that it represents the Atah of Idah. H. 48cm.

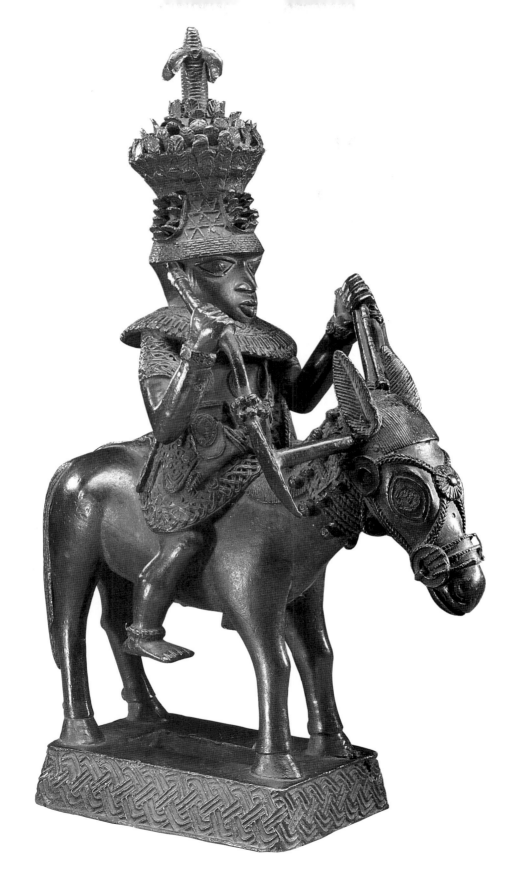

41 This type of figure may be the 'carpenter in the act of striking with an axe' recorded in the *Royal Gold Coast Gazette* account. The 'axe' in question is the blacksmith's hammer, *avalaka*. Scholars disagree as to the identification of the figure. Frank Willett (1967) suggested that it might be a messenger from Ife. More recent work by Blackmun and this author suggests that it might be either a priest of the creator god (Ohẹnsa) or a member of the Ewua association, who call the king to 'open the day', since these are the two groups associated with the palace who wear a cross. H. 63.5cm.

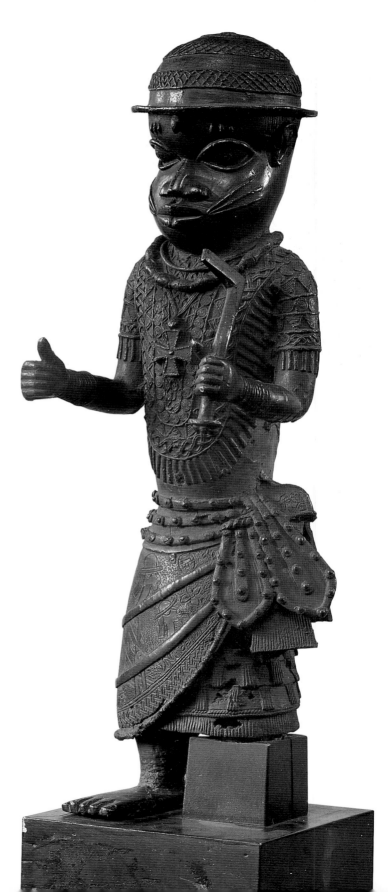

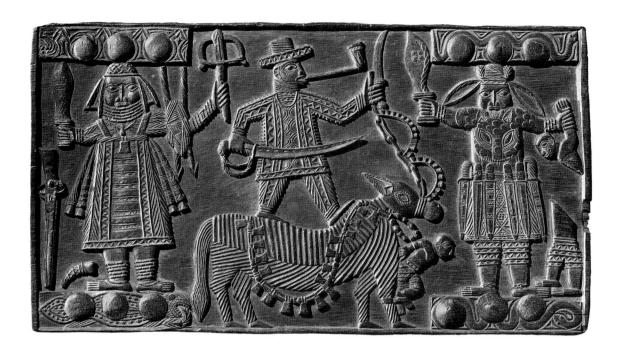

42 Top of Omada-style stool. Omada carvings lack the strict emphasis on symmetry, balance and hieratic composition characteristic of guild work. Figures are frequently portrayed in profile and are seen in poses of movement or even relaxation. Europeans appear (such as the central figure on this stool seat, standing on a horse and smoking a pipe), but they are far from the formulaic Portuguese depicted in guild art. Most unusual is the placement of an Oba on the periphery of the stool rather than at the very centre. L. 63.6cm.

Later, a member of the Punitive Expedition was to record some of the same brass figures on the altars.[41] Whether the accumulation of free-standing statuary is a nineteenth-century development or our knowledge of it is merely a result of selective viewing by earlier visitors is difficult to determine at this point.

Halfway through the reign of Oba Adolo (c.1848–89), the Victorian explorer Sir Richard Burton visited Benin City. He spent some time in a chief's house and left a detailed description of a paternal ancestral altar:

The domestic altar is 'rigged up' in various ways, too various in fact for short description. Some are external, provided with all the heterogeneous mixture of idols: waterpots, pipkins of spirits, cowries, chalk-sticks, ivories, some elaborately and beautifully carved as the Chinese, men's heads coarsely imitated in wood and metal, cocoa-nuts, and huge red clay pipes of Benin make.[42]

Burton's 1862 depiction is not the first by a Westerner, as we have seen; however, it does provide us with a sense of the variety of materials and forms that could be found on altars in the mid-nineteenth century, and which can still be found today (fig. 65).

Oba Adolo appears to have initiated a new artistic tradition in the palace, that of Omada carving. The young men who served as his pages and swordbearers (pl. *emada*) took up carving, presumably under the instruction of members of the Igbesanmwan guild.

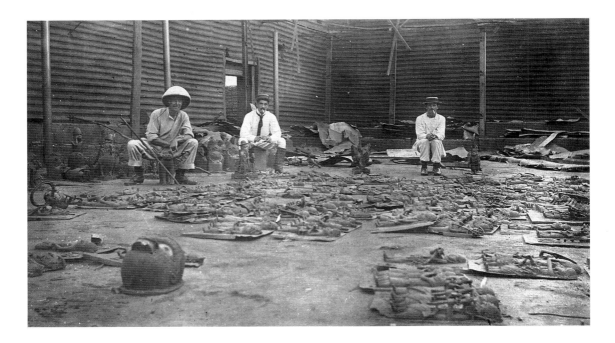

43 Photograph by R. K. Granville taken during the Punitive Expedition, 1897. Brass plaques are strewn across the foreground.

However, by contrast with the guild, their production centred on non-religious objects such as wooden stools, plaques, boxes, beams, doors and incised coconuts and coral beads (fig. 42). The imagery of Ọmada carvings abounds with boats, barrels, parasols, gin bottles, jugs and a variety of weapons. European material goods were clearly a focus of great interest in nineteenth-century Benin, as both archaeological finds and artistic imagery indicate.[43]

At the time Burton was there, and for the following thirty years, Benin's fortunes were in decline. Its political and economic hold on its tributaries was seriously weakened by conflicts along its northern and eastern borders and incursions by the British from the coast. In short, 'the reign of Adọlọ saw Benin driven back into the original Ẹdo heartland'.[44] The British viewed Benin as the main obstacle to their expansion into the agricultural interior and when, in 1897, an envoy to Ọba Ovọranmwẹn was ambushed and killed, the British sent out a Punitive Expedition against the kingdom. The British set fire to the residences of the Queen Mother and important chiefs and, as the fires spread, much of the city was destroyed. The royal palace and the homes of chiefs were looted. The capture of the city and subsequent exile of Ọba Ovọranmwẹn marked the end of Benin as an independent kingdom and the beginning of a new era of social, political and artistic change (fig. 43).

44 Brass ewer. The form of this container and its snake-shaped handle resembles Victorian ewers and reflects the great interest in Western material culture at this time. H. 37cm.

Colonialism and Nigerian Independence

During the siege, many inhabitants of Benin City – the craftsmen included – fled to the villages and farms. With the Ọba gone, the traditional impetus for artistic creation no longer existed and art production stagnated. An entire generation of young craftsmen grew up without the opportunity of seeing art works in their original context or of participating in their production.

The situation changed, however, when in 1914 the British allowed the senior son of the last independent king to assume the throne. As a sign of the renewal he intended to bring about, he took the name Ẹwẹka II, after the first king of the Oranmiyan dynasty. When he had been the heir apparent, Ọba Ẹwẹka II had learned to cast and carve – in fact there is a stool made by him in the Benin Museum – and his interest in sculpture continued long after his period of training. During his nineteen-year reign, Ọba Ẹwẹka played a vital role in reviving the traditional arts and encouraging the transition to new forms.

Upon his accession, Ọba Ẹwẹka faced the challenge of restoring the kingship. One of his first projects was the reconstruction of the palace to some of its former glory, a task for which he needed the traditional craftsmen. Carvers and casters were put to work producing replacements for the shrine objects taken during the Expedition (fig. 69).[45]

At the same time, the new Ọba was aware of the demands of the modern situation. In 1914, in a bold move, Ọba Ẹwẹka II lifted the restrictions limiting the arts to the king and nobility in order to provide a wider base of consumption. Then, in 1916, he erected a shed in the palace courtyard where he allowed the craftsmen to offer their products for sale direct to outsiders. The British colonial officials were anxious to stimulate the economy and in the 1920s financed the establishment of an Arts and Crafts School under the Forestry Department of the Native Administration. Carvers and smiths were paid a monthly wage and their wares were displayed and sold. Guild brass-casters and both Ọmada and Igbesanmwan carvers participated. While they continued to produce religious and prestige objects for the king and chiefs, they were creating at the same time forms for a new clientele: colonial officers, tourists and, eventually, a developing Western-educated Nigerian élite.[46]

Ọba Akẹnzua II succeeded his father in 1933 and continued to embellish the palace. During the late 1940s he commissioned the carver Ọvia Idah (1908–68) to decorate the façade; for this the artist created a series of clay and cement reliefs which continued in format and subject-matter the ancient tradition of plaque making,

depicting heroes and heroines of Benin history, while using a totally new medium (fig. 74). For the front courtyard Idah erected a nearly life-size figure of the famous warrior king Ọzọlua, while at the same time creating a variety of forms in wood, ivory and even bronze for the interior of the palace – some designed for purely contemporary use, like wooden statues as supports for radios.[47]

Idah played a central role in mid-twentieth century Benin artistic developments. As a child he became a page to Ọba Ẹwẹka II, who had just assumed the throne, and while in the palace learned to carve in the Ọmada style. There were few economic opportunities for young men when Idah was released from his palace service and so he went to Lagos, where he became a skilled carpenter and artist and then teacher of art at King's College. While in Lagos, Idah originated such now-popular media as ebony carving and cement sculpting and gained a reputation among young Nigerian artists and expatriates interested in the contemporary art scene. In 1947 he returned to Benin City and was soon appointed as head of the Arts and Crafts School with the assignment of revitalising traditional arts. In 1976 he organised many of the ebony carvers into a co-operative with the aim of obtaining government support and of reaching the growing expatriate community.

The home that Idah built for himself in Benin City created a stir: it was asymmetrical, multi-level, and covered with his own artwork (fig. 45). From his home he sold not only his own creation but that of independent carvers and casters and, in the Olokun gallery at the front of the house, he showed the work of school-trained modern Benin artists. Well-known contemporary artists like Festus Idehen and Felix Eboigbe were influenced by him.[48] During the reign of Ọba Ẹwẹka II the colonial government began teaching Western art traditions in local schools and in 1952 established the first formal art school, Yaba Technical Institute (now Yaba College of Technology). Some of the earliest Ẹdo artists, such as Festus Idehen and Osifo Osagie, studied in Lagos which was, and still is, the artistic centre of Nigeria. Starting in the 1960s, new art galleries opened in Lagos to promote contemporary artists, and by the 1980s these included a National Gallery of Modern Art and an Exhibition Centre. Many Benin artists participated in shows sponsored by these institutions.

Developments in Benin City were slower, but by 1975 the University of Benin had a Department of Creative Arts which continues to train new artists and hold exhibitions. A few private galleries, like that of the well-known sculptor Felix Idubor, exist in the city.

46 Cement sculpture by Princess Elizabeth Olowo, daughter of the late Ọba Akẹnzua II, who encouraged her artistic endeavours. Olowo also works in metal, the traditionally male medium, and, according to LaDuke (1988), was the first woman appointed to the sculpture faculty at the University of Benin.

Contemporary Benin artists have been trained in Nigerian universities or overseas, even though many began by learning at home with a grandfather or other relative. Their patrons were initially expatriates, but as time goes on the Nigerian federal government, as well as local governments and businesses, are increasingly commissioning art work. For example, Erhabor Emokpae has created paintings and sculpture for hotels, banks, the National Theatre, the OAU and Lagos airport, as well as designing the logo for FESTAC.[49] While at the present time there is no 'Benin school' such as the group of artists at Nsukka or Oshogbo, Benin artists are nevertheless strongly represented on the new scene, and indeed some, like Benson Osawe, Festus Idehen, Felix Idubor, Ben Aye and others, have earned international reputations. Gender barriers have begun to break down as more and more women begin to produce contemporary art; even, in the case of Princess Olowo, moving into the formerly restricted area of bronze-casting (fig. 46).

At the same time that these artists are working within a Western art milieu, others are actively creating forms with roots in the pre-Colonial period but which have been reformulated to meet new situations. Thus, Ekpo masqueraders, who once danced solely to combat disease, now travel to Benin City airport to greet high-ranking government visitors. Similarly, as the worship of the deity Olokun thrives, mud shrines in his honour are constantly being created and expanded.

Ọba Erediauwa, who assumed the throne in 1979, has brought new energy and commitment to the royal ritual cycle. His interest has revived craft guilds like Owinna n'Ido, the weavers, and stimulated the production of regalia. It is an unfortunate sign of the times that some of this new guild creativity has been forced on the Ọba by the international art market's desire for Benin art which led in 1976 to a second looting of royal treasures from the ancestral altars.

Like his father, Ọba Erediauwa wished to improve the exterior of the palace and so has added large carved relief doors to his refurbished waiting room.[50] In addition, he initiated the renovation of major public shrines and placed cement statuary at central locations throughout Benin City.[51] These exciting new developments in the arts call out for further research.[52]

45 The house in Benin City constructed by Ọvia Idah. On the veranda are cement sculptures of an elephant attacking a man.

CHAPTER 2
ART, BELIEF AND RITUAL

In Benin cosmology there is a basic dichotomy between two planes of existence: the visible, tangible world of everyday life (*agbọn*) and the invisible spirit world (*ẹrinmwin*), inhabited by the creator god, other deities, spirits and supernatural powers. These are two parallel coexisting realms. Their boundaries, however, are not inviolable, as gods and spirits daily intervene in the lives of humans, and particularly powerful humans draw upon the forces of the spirit world to transform daily experience. The relationship between these two spheres constitutes the dynamic of Benin religion.

The world as it is known to the Ẹdo – the cosmological realms, geographical borders and sociopolitical hierarchies – was created by Osanobua, the high god. According to one version of a widely told myth, in the beginning there was no land, only primordial waters. At the centre of the waters stood a tree and on its top lived Ọwọnwọn, the toucan. When Osanobua decided to populate the world, he gathered his three sons and sent them off in a canoe. Each was given the choice of one gift to take with him. The two elder sons chose wealth and craft tools. As the youngest prepared to choose his own gift, Ọwọnwọn cried out to him to take a snail shell. This he did, and when the canoe reached the centre of the waters, the youngest son turned the shell upside down and out poured an endless stream of sand. In this manner, the land began to emerge from the waters. The sons of Osanobua were afraid to go out from the canoe, and so the chameleon was sent to test the firmness of the ground. From that time on, it walks with a hesitating step. The place where the land emerged was called Agbọn, 'the world', a name since changed to Agbor, today an Igbo town to the east of Benin City. At Agbọn, Osanobua first came down from the sky on a chain and demarcated the world. It was from there he sent people to the four corners of the earth, to every country and geographic realm. He made his youngest son the ruler of Benin, the owner of the land. And he established his own realm, the spirit world, across the waters where the sky and earth meet.

Osanobua is envisaged as living in a magnificent palace, surrounded by courtiers and served by other deities. He is the father of the other gods, among them Olokun, his senior son, who provides wealth, health and fertility, Obiẹmwẹn, his oldest daughter, who ensures safe childbirth, and Ogiuwu, who is the lord of death. For humans, Osanobua is a remote god, primarily concerned with the spirit world, having delegated his children to care for the world of everyday life. There are no organised groups worshipping him, no regular meetings and no public priesthood. Prayers to him open

47 Brass kola nut box in the form of a fluted gourd. Kola nuts are a major feature of offerings, both in ritual and for hospitality. The fluted gourd is the characteristic oblation to Osanobua, to whom it is offered in lieu of a cow, the highest level of domestic animal sacrifice. Thus, this container is a visual play on the concept of offering. H. 19.1cm.

every religious service, but these are primarily gestures of respect rather than active requests. Osanobua is appealed to only as a last resort, when all else fails. Unlike the other gods and spirits he never demands human sacrifice, a sign that he is remote as well as utterly benevolent.

In the front courtyard of most compounds is a shrine to Osanobua called Osagbaye. It is not elaborate, consisting only of a long pole stuck into a mound of sand. At the top of the pole is a pure white cloth which flutters in the breeze like a flag. The shrine evokes the creation myth: a solitary tree in the sand emerging from the primordial waters. The white sand and cloth are cool, peaceful, ritually pure. While Osanobua is like other African creator gods in that he is removed from daily life, he differs from them most radically in that he is actually depicted in art. Images of Osanobua appear in the form of Ekpo cult masks and as life-size mud figures in shrines dedicated to his senior son, Olokun, lord of the great waters (fig. 48).[1] It is interesting to note that in this shrine, Osanobua is seated to the rear of Olokun in a clearly subordinate position. In the words of the Benin adage, 'One can indeed bear a child greater than oneself as Osanobua bore Olokun'.

Olokun is the most popular and widely-worshipped deity in Benin.[2] His role is indeed greater than that of his father. In Benin cosmology, Olokun is identified with the great oceans of the earth which surround the land and into which all the rivers flow. More

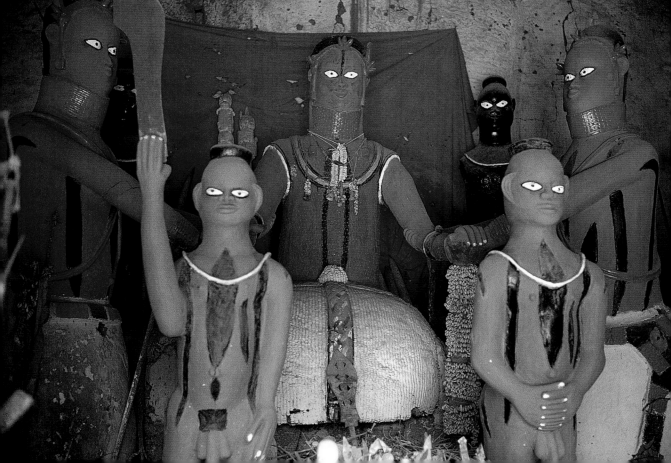

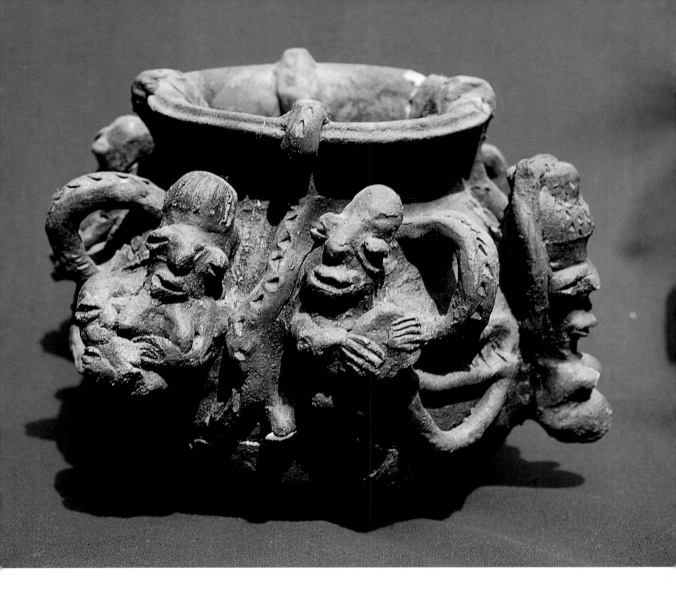

50 Olokun ritual pot made by a female member of the brass-casters' guild. Not all Olokun pots are decorated with figures, but all share the same basic shape: squat and full-formed body, narrow top, and incised ornamental lugs. The figures on the pot represent scenes of Olokun worship: priestesses, musicians, and devotees who have received the main gift of Olokun: children. The pythons which descend the rim are messengers of the god. H. 24.2cm.

48 OPPOSITE TOP Mud shrine dedicated to Olokun in the home of the priestess Igheghian Uwangue, made by her husband Iyamu Ehigatọ. Osanobua appears to the right of the central figure, Olokun. The mud construction is covered with lead paint symbolising permanence, as expressed in the Edo saying, 'Lead never rots, brass never rusts'.

49 OPPOSITE BELOW Olokun shrine in Evboesi Village, one of the major shrines in Iyekorhionmwọn District.

specifically, he is associated with the Ethiope (Olokun) River in the south-eastern part of the kingdom, which is considered the source of all the global waters. The path to the spirit world lies across the sea and the souls of those who have died, as well as those about to be born, must pass over the water. It is this last association which explains why Olokun is considered to be the provider of children to the Ẹdo, for whom large families are a source of wealth and prestige. Olokun is similarly considered the source of riches and good fortune since before making this crossing the soul may be blessed by him, ensuring luck, wealth and success. It has been suggested that the particular association of Olokun with wealth may be due to the coming of European trading ships across the sea.[3] In offering children, health and wealth to his followers, Olokun differs perhaps in degree but not in kind from other Benin deities. But in one area he stands out and that is his demand for beauty in all its forms: graceful movement in dance, 'sweet' songs, elaborate shrine decoration, rich fabrics and, most of all, beautiful women. Exceptionally beautiful women are said to have been sent to earth by Olokun as his special devotees.

Although both men and women are worshippers of Olokun, he is widely considered in Benin to be the special concern of women because of his role in providing children. Parents of a female child instal a small shrine to Olokun for her protection and future well-being. At the time of marriage, a woman transfers this shrine to her husband's house, where it assumes even greater importance with her new married status. The shrine consists of a whitewashed mud altar upon which are placed pieces of kaolin chalk, a symbol of purity and good luck, and a special ritual pot containing fresh river water (fig. 50). These pots are made in various villages specialising in pottery making, by female members of the urban brass-casters' guild, or by priestesses who have been 'chosen' by the deity for this craft activity. While all traditional women in Benin have Olokun altars in their homes, some of them become particularly involved in his worship because of health or sexual problems, difficulties in conception, or a 'calling' expressed in states of possession. These women join local congregations which are headed by a chief priestess and which meet every week for purification and possession rituals. A man with similar problems might also seek help through membership but will rarely become as actively involved.

In the area of Iyekorhiọnmwọn near the Ethiope (Olokun) River, the worship of Olokun is organised on a village level. All members of the village, male and female, participate, with the

oldest man and woman often designated as chief priests. In many of these villages there are elaborate mud shrines of up to forty life-size figures (fig. 49).[4] These tableaux depict the palace of Olokun under the sea, a kind of paradise of purity, beauty, joy and wealth. All the beautiful women and children are there, to be sent by the god to his devotees on earth. Also there is the storehouse for all the riches of the world, including most notably the coral beads which adorn the king of Benin and give him his authority.

At the centre of these altars stands the figure of Olokun, larger than life, his arms supported in the traditional ceremonial stance of deference. As the senior son of Osanobua, and ruler in his own right of a vast realm, Olokun is represented in the form of a Benin king in full ceremonial regalia. Particular emphasis is placed on his beads, which are famous in oral tradition for their beauty and abundance. Behind the king stand his wives and female attendants and to his side his numerous chiefs and courtiers. The range of different personages portrayed varies from shrine to shrine, but can include court musicians, jesters, peace officers, executioners, lame gatekeepers, soldiers and various titled chiefs. Mud shrines of this type, but with fewer figures, are found also in the homes of chiefs in Benin City, where they form only part of a series of altars dedicated to various deities and mystical powers, and represent their owners' wealth and rank. Within recent times, chief priestesses of urban congregations have also begun to erect mud altars in response, they say, to demands by the god.

Olokun, like his father, Osanobua, is considered a 'cool' god, that is, they both represent the positive aspects of experience: ritual purity, good luck, health, long life, prosperity and happiness, all symbolised by the colour white. In sharp contrast stands Os-anobua's other son, Ogiuwu, bringer of death. Ogiuwu is no longer prominent in Benin worship and it is difficult today to learn much about his cult in former times. A shrine once existed in the central part of town where many human sacrifices were offered. Ogiuwu is said to be the owner of the blood of all living things. He uses sacrificial blood to wash down the walls of his palace, and has a particular preference for that of humans. While Ogiuwu himself never appears in artistic form, his messenger Ofoe does (fig. 52). Ofoe is sent by Ogiuwu to take human life and thus he is represented as the pursuer, a figure with no body, only legs with which to chase his victim and arms with which to capture him. 'Ofoe has no mercy and yields to no sacrifice or entreaty.'[5]

Just as the colour white symbolises the qualities of Osanobua and Olokun and black those of Ogiuwu, so red embodies and

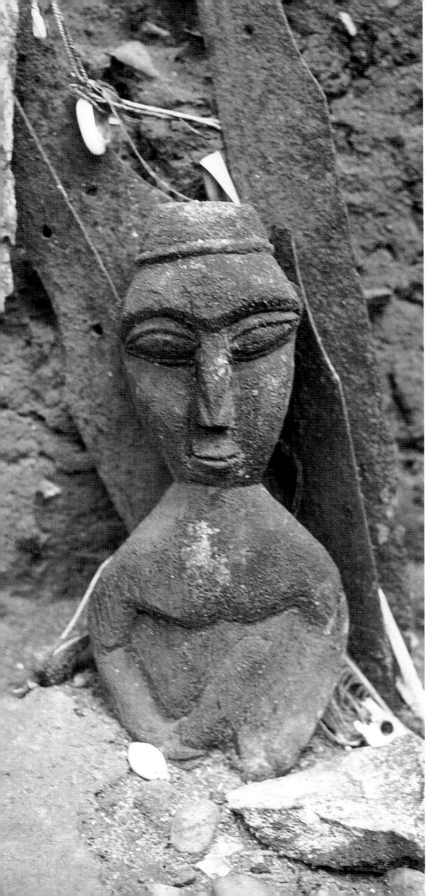

51 Wooden statue of Esu placed in front of a chief's home in Benin City as protection against unwanted intrusion. Depictions of Esu in Benin cosmology range from a trusted gatekeeper to the spirit world to a havoc-maker (the latter interpretation of his nature may have been influenced by Christian theology). (Izevbegie 1978.)

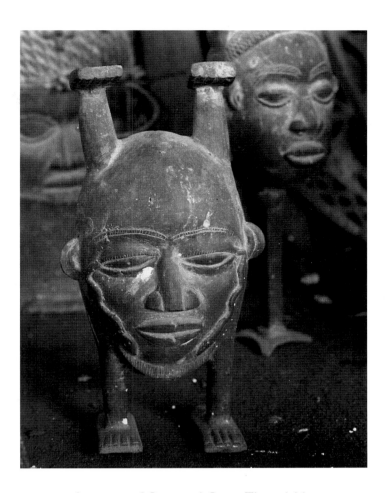

52 Brass bell in the form of Ọfọe, messenger of the god of death, from the royal ancestral altar to Ọba Ẹwẹka II, photographed in 1970. The figure symbolises the king's power of life and death over his subjects.

expresses the nature of Ogun and Osun. These deities are associated with sudden and violent action, anger, fire and blood. Ogun and Osun partake of both the beneficent qualities of Osanobua and Olokun and the harmful potential of Ogiuwu. Theirs is an ambivalent nature in the literal meaning of the term, for they are equally as capable of inflicting instant death as providing health and riches.

Ogun is the patron of farmers, craftsmen, hunters and warriors – all those who depend on tools.[6] In Benin thought, Ogun is conceived in both abstract and anthropomorphic terms. As an abstract concept, Ogun represents the force inherent in metal, a mystical power with the potential to create or destroy. In this capacity, Ogun cannot be artistically represented except indirectly through those objects in which the power of metal resides, such as ceremonial swords (fig. 13) or proclamation staffs (fig. 73). Ogun

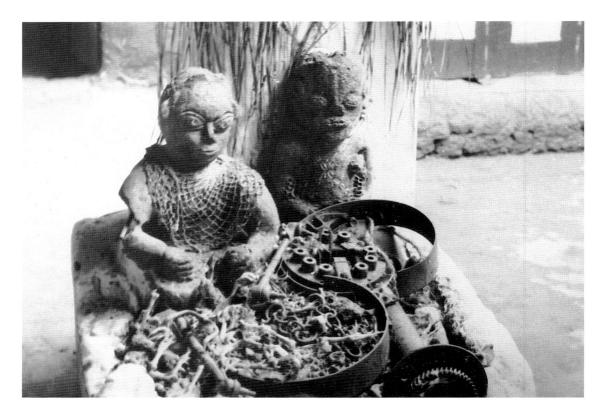

shrines consist of heaps of scrap metal and are found both separately and as an essential part of altars dedicated to all other Ẹdo deities. As Chief Ihama pointed out, 'In every shrine Ogun is always first. It opens the way.' Yet Ogun also appears in the oral tradition as a junior son of Osanobua sent out into the world with his cutlass to make farms and to make war. In this capacity, Ogun can be found portrayed in mud shrines either devoted to him or, more commonly, in those dedicated to his senior brother, Olokun. In these he is always depicted in a red war-costume, carrying the tools and weapons of his varied occupations. Not only his costume but, significantly, his eyes are often painted red. To describe someone in Benin as having 'red eyes' is a way of indicating his violent temper and his capacity for causing harm. Ogun's dangerous power, however, can be used to protect his devotees, just as his sword can open the way to a better life.

Like Ogun in his abstract form, Osun is not an anthropomorphic deity but a power which inheres in leaves and herbs collected in the forest. Specialists, called *ebo* in Ẹdo, possess knowledge of the location of these ingredients and how to brew them into magical

53 Mud figures on an Ogun altar in a chiefly compound in Benin City. Heaps of scrap metal constitute the focus of the altar.

54 Brass cup used by Osun specialists for *ewawa* divination. Small brass images of humans or animals, cowries, and other objects are shaken in the cup and thrown down onto a drum. The resulting arrangements of images are analysed.

and medicinal preparations. Both Ogun and Osun, then, are concerned with the processing of raw materials and with their transformation into instruments of power. While Ogun's powers are manifested on the physical level, in tools and weapons, those of Osun are psychic or spiritual. *Ebo* use their special knowledge to cure, to divine, to administer ordeals to suspected evildoers, and indeed to deal with the greatest evil of all, the witches, *azẹn* (figs 54, 55).

The Ẹdo believe that *azẹn* operate at night in the wild forest. Their society is organised on hierarchical lines, with a king, chiefs, warriors and magicians – a grisly parallel with the human world. At night the witches meet in tree tops and send out their life-force in the guise of a vicious night bird to take the life-force of their intended victim and transform it into a passive animal, such as a goat or antelope, which they then devour. Because of his knowledge of the forest, the Osun specialist shares the same powers as the witch but uses them only for good ends.

One locus of the Osun specialist's power is his iron staff, *osun ematǫn*, (the iron *osun*). It is a long rod surmounted by a bird,

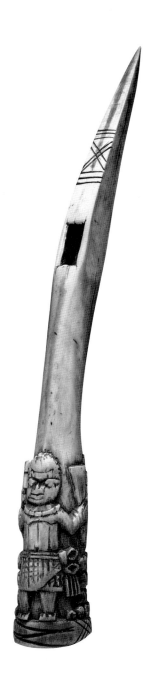

55 Ivory side-blown horn (*oko*). Osun specialists use these horns, made of ivory or wood, to announce to the witches that a ceremony is about to begin. H. 36.8cm.

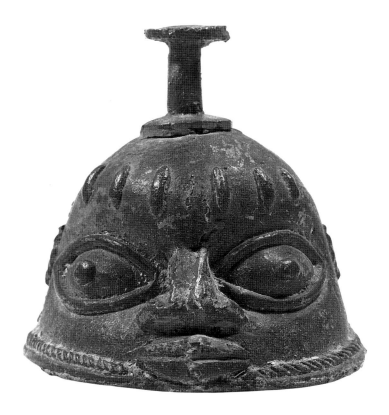

sometimes astride a horse, and decorated with figures of other birds, animals, reptiles and a variety of objects of ritual and everyday use, such as ceremonial swords and hoes (fig. 56). The use of iron links the Osun specialist with the warrior, hunter and craftsman, all of whom have Ogun as a patron deity. The staff itself represents flames shooting upwards. Its praise-name is *osun nigiogio*, the *osun* burning up with heat. The staff gives the specialist the power to escape danger and confront the evil world of the witches. In pre-colonial times, warriors used to carry these with them to ensure success in battle.[7]

Veneration of these various deities has undergone changes throughout Benin history, although we have very little information about past beliefs and practices. While some gods, like Ogiuwu and Obiẹmwẹn, have fallen into abeyance, others have been introduced from outside and are now widely worshipped, such as Esango (Yoruba Shango) and Esu (Yoruba Eshu) (fig. 51), Mamy Wata and Jesus.

In addition to these generally-worshipped deities, there are numerous more localised ones: deified founders of ward guilds in Benin City and great war heroes, magicians and faithful servants of past Ọbas, particularly Ẹwuare and Ọzọlua. Also worshipped are

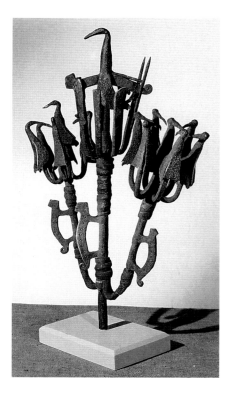

56 Iron Osun staff (*osun ematọn*). The power of the staff enables the Osun specialist to transform into a bird or animal. The bird depicted on the top of this staff is *akala*, lord of the witches. Chameleons along the sides of the staff represent the power of transformation.
H. 67cm.

57 Ovbo performers from Uzala village.

rebel warriors and fugitive queens, who fled the court into the countryside and there transformed themselves into features of the environment: rivers, lakes, and hills.

Village Arts

The last-named types of deity – the faithful and the rebellious – are the focus of rural worship, some in one village only, others in a group of contiguous villages, and still others spread over one of the large traditional subdivisions of the kingdom. These hero deities (*ihẹn*) are venerated by the community in order to ensure the health and well-being of all village members (figs 57, 58, 59, 61).

There are certain art forms associated with these hero deities. Most common are staffs of authority (*ukhurhẹ*) which are long and segmented with a hollowed chamber just below the top in which a piece of wood is inserted to make a rattling sound when the staff is struck on the ground. These are different from the more commonly seen ancestral staffs, as they are much thicker and have a figure of a priest or other object specific to the cult as a finial (fig. 61). This is the most widespread and, indeed, most basic form of all Benin cult objects.

The rattle staff is both a means of communication with the spirit world, achieved when the staff is struck upon the ground, and a staff of authority, to be wielded only by properly designated persons. In this way, it is related to a variety of royal staffs of authority. Ideally, these cult staffs are obtained from the urban carvers' guild, Igbesanmwan, who are supposed to have a monopoly on their production, but in fact local village age-grade members often produce them when needed for their own rituals.

Most village shrines consist of these rattle staffs, pots with magical ingredients and pieces of kaolin chalk. In some of them there are also mud figures similar in form to those found in Olokun shrines, discussed earlier. In fact, mud figures are mainly found in the shrines of river deities, such as Igbaghọn, who are considered members of Olokun's court. Thus, they are never represented in the royal pose and regalia of kings, as is Olokun, but in the secondary but still imposing role of chiefs, queens or powerful herbalists.

There are a number of different village masking traditions. Whatever the deity involved, the mask wearers are usually called *ẹrinmwin*, that is, representatives of the spirit world. The ceremonies in which they perform honour the hero deities as well as purify and protect the village from the evil forces that bring disease. For this reason the dancers' bodies are covered by a cloak of palm fronds,

the smell of which is said to repel evil. In some cases, the palm fronds are overlaid with streamers of scarlet ceremonial cloth on which are sewn mirrors and brass cut-outs; again, all these materials are supposed to repel evil. Wood is used to build superstructures to which are attached voluminous silk scarves, as in the Okhuaihẹ ritual performance, or rows of red parrot feathers, used in the headdresses of Ovbo n'Uzala (fig. 57) or Ọvia dancers (fig. 61). Actual wooden masks are used in Ekpo n'Igan and Ekoko n'Ute, two village masking groups that come into Benin at the annual ceremony of Iguẹ to entertain the crowds, as well as in two festivals of village cults which derive from other regions: Igbile of Ughọtọn Village (fig. 58) based on Ilaje Yoruba and Ijo elements, and Eghughu of Iguẹ Osodin, derived from the Owo Yoruba Egungun masquerade.

The most widespread and best-known ritual with wooden masks is Ekpo, found mainly in the region of Iyekorhiọnmwọn, an area to the south and east of the capital city, which long rebelled and fought against the central power.[8] The founder of Ekpo was Agboghidi, a famous warrior who rebelled against Ọba Akẹngbuda (c.1750) from his base in the village of Ugo in Iyekorhiọnmwọn. From Ugo his warrior associates took the worship of Ekpo to other villages in that region. Ekpo is said to protect villagers from disease. At the annual dances, or whenever an epidemic threatens, the men of the middle age-grade don masks representing a wide range of characters: Agboghidi the founder, Olokun, Osanobua, Igbaghọn and other deities, court officials, sacrificial animals, famous Osun specialists (fig. 59), beautiful young women and men in the prime of life.

Ekpo, Ọvia and Okhuaihẹ, as well as others mentioned above, are associated with heroes or heroines who opposed the central government or deserted the Ọba. It is no wonder, then, that they are not allowed in Benin City. Should any mask or other ritual object be brought into the capital, a special ceremony of purification must be performed. Yet these village groups are linked to the centre; all must announce their annual ceremonies to the king and receive his approval. And the Ekpo in particular establishes this link with the urban centre through its iconography. Masks are carved to represent not only the rebel hero who founded Ekpo, but also to portray past chiefs, Osun specialists and warriors, who mediated between the village and court and utilised their special powers on behalf of the king. In more recent times, a form of Ekpo performed by children wearing small masks, mostly from the Ibibio village of Ikot Ekpene, is found in Benin City during the Christmas

58 Igbile performer. This mask is worn during the annual ritual in Ughọtọn Village honouring their local deity, Igbile. Ughọtọn (Gwatto) was once the port of trade with Europeans, but may also have been a cultural contact point with other riveraine groups long before that time. The dancers sing in a language that they identify as Ilaze (Ilaje Yoruba). Fagg (1963) suggests that the masks show strong stylistic affinities to the art of the Niger Delta.

59 An Ekpo mask representing an ọbo (singular of ebo) dressed in black and with a headdress embedded with charms for protection against witches and other bringers of disease.

vacation. In response to the new political reality, groups of masqueraders from villages such as Avbiama now drive to the capital to perform at ceremonies to greet visiting dignitaries at Benin City airport.

The Arts of Temporal Experience

Erinmwin, the world of the gods and hero deities, is ever present but invisible. It impinges on the everyday world as its denizens make demands and punish those who refuse to fulfil them. Sacrifice is the human way to appease these gods and request further favours. The relationship is contractual: in return for long life, health and prosperity, humans give respect and gifts.

But there is also a temporal dimension to the human relationship with the spirit world.[9] Each human soul must move between the two realms in a cycle of fourteen reincarnations. Before birth, a person comes before the creator god, Osanobua, and his senior son, Olokun, to inform them of his or her life's goals or destiny. This is not predestination in the Calvinist sense, since a person chooses his or her own fate, which is then confirmed by these two deities. The person's *ehi*, the alter ego or 'guide' in the spirit world, stands beside the individual and thereafter keeps track of how well that person has fulfilled the destiny that he or she has chosen. Intimately linked with individual destiny are the Benin notions about the mystical aspects of the human personality as embodied in the Head and the Hand.

Blessing one's Head is an Edo rite to celebrate a joyful achievement, such as the birth of a child or a safe return from a dangerous journey. There is also an annual ritual, Igue, to celebrate the successful completion of one year and the beginning of another. 'The head stands for the ability to order one's life and that of his or her dependants in order to achieve. It stands for the victory of the power of thought (*iroro*) over brutal force. It is what helps a person to make a good ancestor.'[10]

Shrines to the Head are found in the most private chambers of chiefly homes. On the altar there sometimes rests a carved wooden head, of exactly the same type as found on the ancestral altar, which is a direct representation of the successful life of the chief as expressed in his 'good Head' (fig. 62; cf. fig. 68).

If a man has led a successful and prosperous life, he can then erect a shrine to his Hand, the representation of individual achievement in the worldly sense: the possession of slaves, wives and animals. It is individual decision, not divine demand, that dictates when this altar will be erected; the person must feel he has indeed

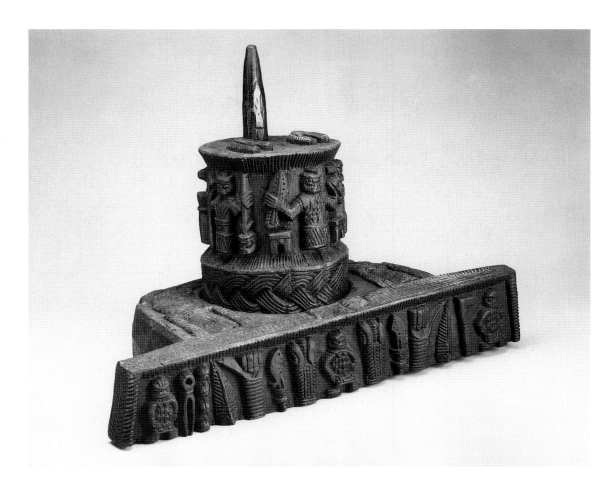

60 Wooden shrine of the Hand (*ikẹgobọ*). The imagery of this *ikẹgobọ* refers to the wealth and success of its owner, who is represented as the central figure on the front. He is accompanied by his followers, one supporting his arm and the other holding a spear plunged into a decapitated head. At his sides are padlocked chests, containing his wealth. On the base symbols of offerings (figures holding kola nuts, leaves and animal heads) alternate with the implements of ironworkers and the powerful hand that 'gathers up wealth'. H. 50.8cm.

accomplished much in this world. The shrine of the Hand is generally carved in wood, although those apparently made for an eighteenth-century Ọba and Ezọmọ (figs 1, 32) were cast in brass. The shrine, called *ikẹgobọ*, consists of two parts: above, a wooden cylinder upon which is carved the image of a successful warrior chief, and below it, the rectangular or semi-circular base, with a frieze of sacrificial animals representing all the creatures which the powerful chief has offered to the spirit world. The main image, of course, is a pair of hands with upraised thumbs, representing the gesture of 'gathering up riches into one's own hand' (fig. 60).

When an individual, successful or not, has reached the end of his time on earth, his body is buried and his soul returns to the spirit world to give an account of his life. His *ẹhi* must testify as well. Those who have lived well can hope to return again to the everyday world, in many cases to their own families, to live out their cycle of

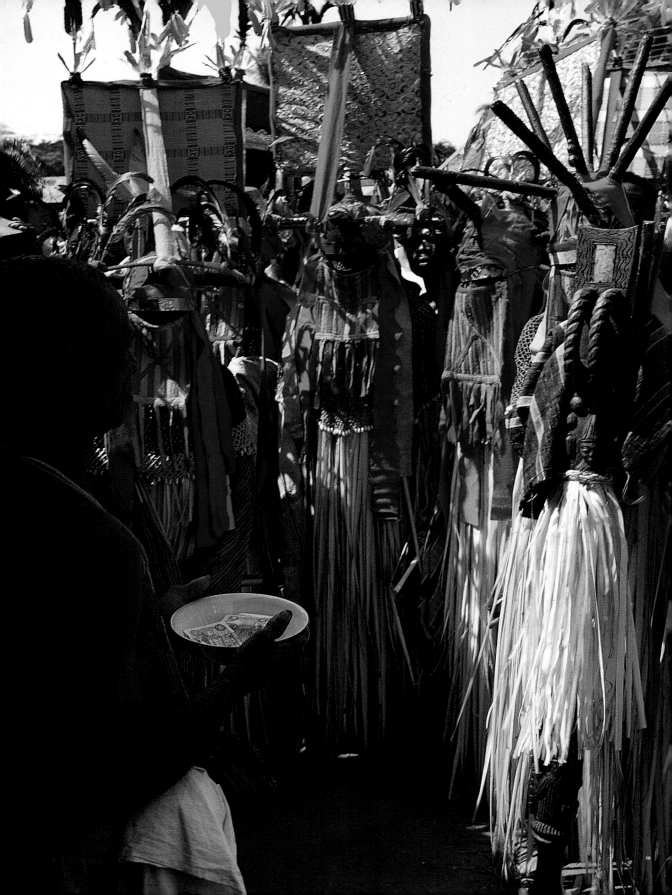

61 Ọvia rattle staff held by a priest. Bradbury (1973) explains that 'The *ukhurhẹ* [rattle staffs] are the real symbols of Ọvia . . . They are massive staffs about four-and-a-half feet high carved with representations of Ọvia masqueraders. More than anything else, they are identified with Ọvia herself who is sometimes said to enter them when she is called upon by the priests'.

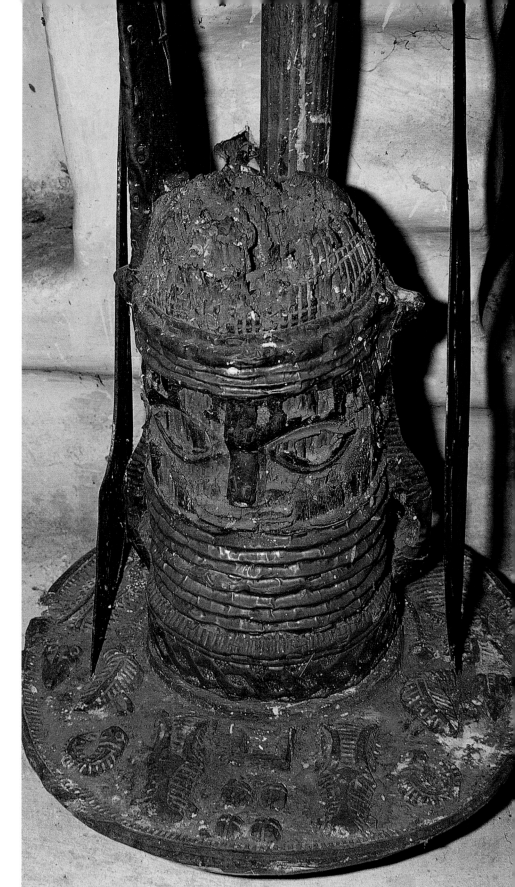

62 Wooden shrine of the Head in Benin City. The carved head rests on a special plate (*ọkpan*) with designs of kola nuts and sacrificial animals.

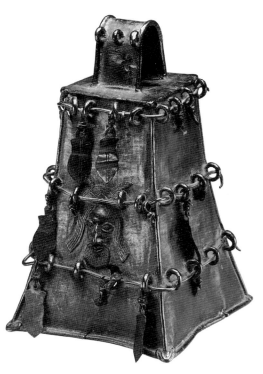

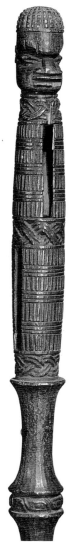

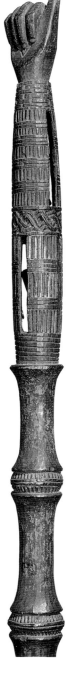

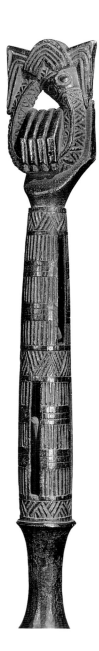

63 Brass bell. Like the rattle staff, the bell on the ancestral altar is used to call the ancestors, but this sort of bell also has warrior associations, for in pre-colonial times warriors used to wear bells around their necks for protection in battle and to announce their victories on returning home. An image of a Portuguese is in the centre of the bell and brass cutouts of ceremonial swords (ẹbẹn) are attached to wires on the surface. H. 18.4cm.

64 Three rattle staffs for ancestral altars. The one on the left surmounted by a human head represents generalised ancestors and is for a commoner's paternal altar. The one in the middle with an upraised thumb is for titleholders and is associated with the gesture of 'gathering up riches' found also on altars of the Hand. The one on the right is also reserved for titleholders and illustrates the proverb or curse about ancestral power: 'The one who holds the fish can also let it loose'. H. of tallest 133cm.

fourteen reincarnations. Evil-doers may be doomed never to return. On earth, the survivors perform an elaborate funeral ceremony to guide the soul to the spirit world and to ensure its incorporation as an ancestor (fig. 66). The senior son sets up an altar as the focal point for communication with his father; if a family altar already exists, he will simply add a carved rattle staff.

The art objects found on the Benin ancestral altar in large measure reflect the hierarchical social structure of the kingdom. The commoner's paternal ancestral altar is a rectangular platform. Resting upon the wall are wooden staffs, *ukhurhe*, with a human head carved on the top of each of them (fig. 64). If any predecessor of the present senior son had a title or was a well-known priest, his ceremonial swords, either *ada* or *eben*, might be found among the staffs. At least one rectangular bell is placed towards the front, where it can be easily rung to announce the commencement of a service (fig. 63). At the very front, the presence of a celt or 'thunderstone' signifies the sudden and dreadful power of Ogiuwu, the god of death.

The paternal ancestral altar of a chief has the same rectangular shape and contains the basic rattle staffs, bells, celts and, of course, ceremonial swords as that of the commoner (fig. 65). But the altar

65 Chief's paternal ancestral altar.

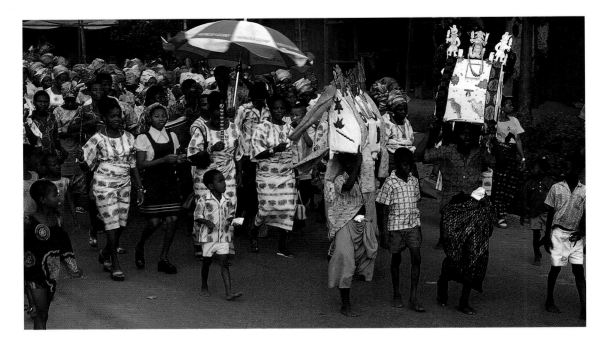

66 The Isoton procession takes place on the fifth day of the second burial ceremonies. Sons of the deceased gather supporters and musicians around them and parade through the streets of Benin City preceded by young boys carrying a box draped in white cloth covered with figures cut out of brass sheets representing aspects of the god of the sea and his world. The box contains gifts for Olokun, before whom the deceased must appear to give account of his or her life.

67 Chief's maternal ancestral altar, Benin City. Hens represent the preferred sacrifice for a shrine dedicated to a female.

68 Wooden
commemorative head
(*uhunmwun-elao*).
Although the local
historian, Chief Jacob
Egharevba (1968),
traces the origin of these
to the Ogiso dynasty,
members of the
woodcarvers' guild
disagree. According to
Chief Ohanbamu Inẹ,
the Ọdiọnwere (senior
elder), the form
represents the head of
Enekidi of Ogbelaka, a
legendary figure said to
have lived during the
time of Ọba Ọzọlua
who was put to death
after an unsuccessful
rebellion (pc1966).
While the carving now
has a decorative and
commemorative
function, this story
alludes to the trophy
head complex discussed
in fig. 14.

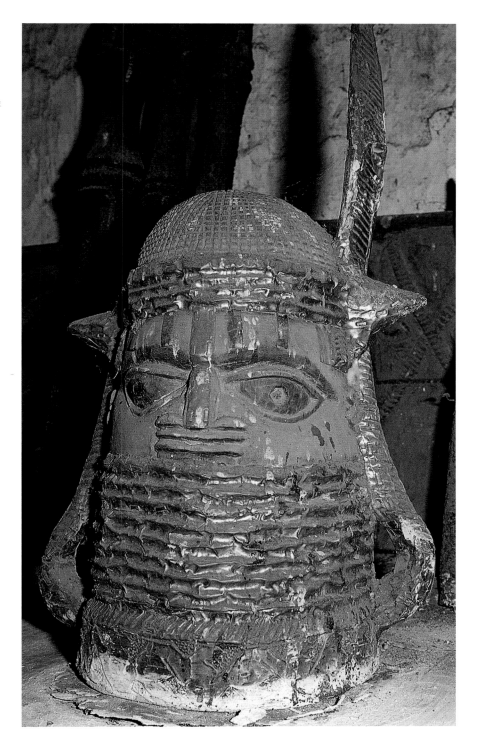

also contains objects forbidden to the commoner. A wooden commemorative head, of the same type as found on the shrine of the Head except that it does not rest on a special plate, is one of the main features of a noble's altar (fig. 68). This carved head, *uhunmwun-elao*, is considered today to be primarily decorative and not spiritually powerful. The altar is related to that of the Head in that it represents the proper and successful life of a chief who has now gone to reside in the spirit world. A special round stool, *erhe*, is placed directly in front of the altar for the use of the chief when he officiates as family priest (see fig. 65, front). The shape differs from the rectangular carved stool used by chiefs as status symbols, but it is associated with the round whitewashed mud seat, called by the same name, which is used by priests and priestesses of Olokun. The appearance of a stool so closely linked with the god of the waters evokes the image of the soul's voyage across the sea to the spirit world. Lastly, behind the altar is a long rectangular carved plank, *urua*. This is found only on the shrines of very high-ranking chiefs, and the sacrificial images carved on it allude to the powers these chiefs have over life and death.

Although Benin is a patrilineal society, mothers play an important rôle in their sons' lives, and, indeed, are seen as significantly contributing to their sons' spiritual and material success. Some chiefs – and, most prominently the king – erect altars in commemoration of their deceased mothers. These altars parallel altars for deceased kings in their decoration with brass heads and altar tableaux (figs 22, 70).[11]

The royal paternal ancestral altar differs considerably from those of commoners or chiefs. It is round, not rectangular, in shape and is adorned with many objects not found on other types of altar (fig. 69). Commemorative heads here, as on the chief's shrine, refer to the powers of the Head to direct life successfully. Those on the royal shrine, however, are made of brass not wood, a usage restricted to royalty (figs 39, 69). Brass has a complex symbolic meaning in Benin. As a material that never corrodes or rusts, it stands for the permanence and continuity of kingship. Its shiny surface is considered beautiful, and in the past the royal brasses were constantly being polished to a high sheen. Lastly, brass is red in colour and this is considered by the Ẹdo to be 'threatening', that is, to have the power to drive away evil forces.

On the top of each head rests a carved ivory tusk. In the old days the king used to receive one tusk from every elephant killed in the kingdom; some were sold to European traders during the long years of commerce with the West, others were given as gifts to faithful

69 Royal ancestral altar for Ọba Ẹwẹka II in the palace, Benin City. Before 1897 there were individual altars for each deceased king, but there is now only one for the rulers since Ọba Adọlọ and a general altar for all those preceding him.

70 Centrepiece for the ancestral altar of a Queen Mother. The central figure of the Queen Mother is represented in her full ceremonial regalia: a beaded choker (*odigba*), coral beaded shirt (*ẹwu ivie*), crossed coral bead strands (*ikpọn egbe eveva*), and coral beaded crown in the shape of a chicken's beak (*ukpẹ ọkhọkhọ*). Only the Queen Mother, the Crown Prince and the Ezomo are permitted to wear a beaded shirt and crown. The Queen Mother stands between two rows of female attendants (*ibiẹka Iyọba*). H. 34.3cm.

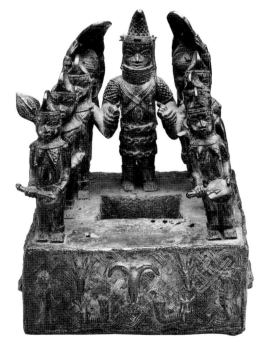

71 A pair of brass or ivory leopards used to be placed at the side of the king when he sat in state, exactly as in the altarpiece tableau in fig. 35. According to Fagg (1963), each of the leopards shown here is made from five separate tusks. Their spots are copper discs and their eyes mirrors. He suggests that these are nineteenth-century copies of earlier models. H. 81.5cm.

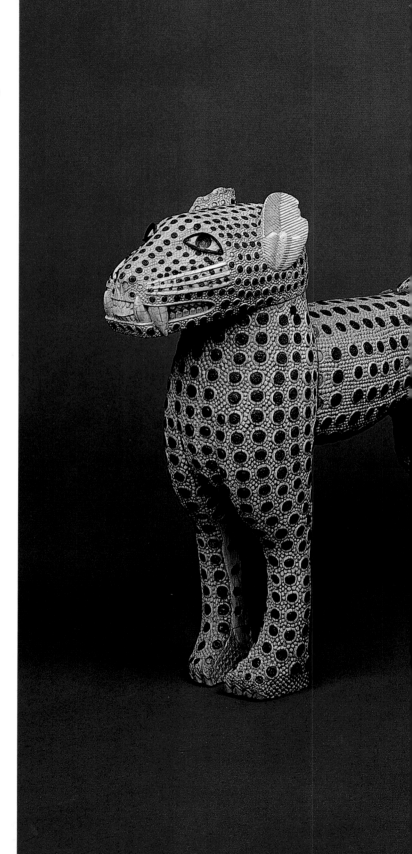

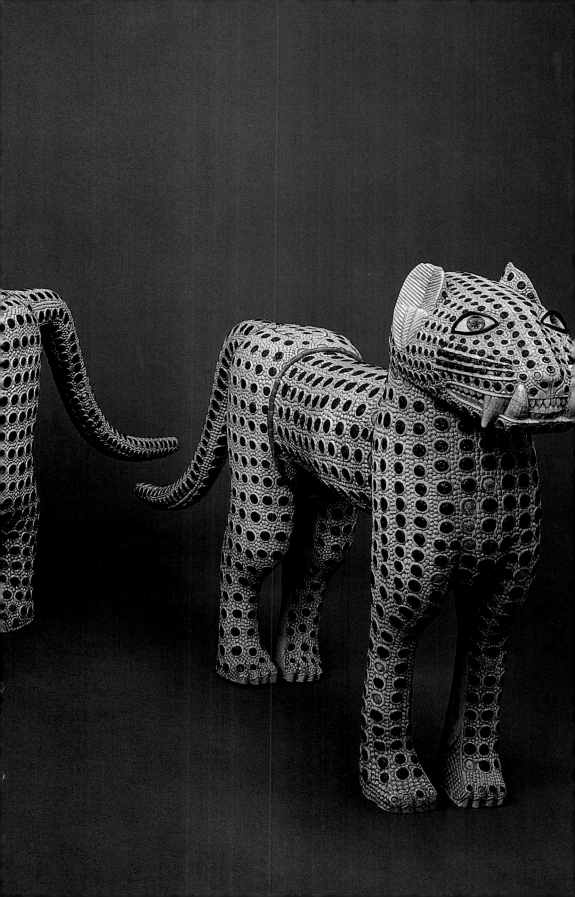

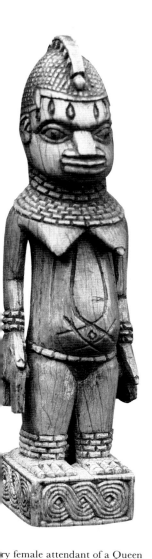

... ry female attendant of a Queen ... : Young women were sent to the Mother's court, where they served ... attendants, pages and servants. een Mother cared for them until ached a marriageable age at which ... r son, the Ọba, could marry them ... them to important chiefs to ... alliances. This figure wears only eads, an indication that she is a geable virgin.

chiefs, and still others were displayed on the royal ancestral shrines. Images on the tusks represent former kings, great war chiefs, soldiers, retainers and animals symbolic of royal powers. 'The whiteness of ivory associates it with a ritual kaolin substance called *orhue* which symbolises joy, peace, purity and prosperity. *Orhue* is rubbed on the body . . . According to Ihama of Ihogbe, the tusks on the Ọba's ancestral altars are washed and bleached before major festivals and sometimes *orhue* is applied to the surface.'[12]

In the centre is a brass altarpiece tableau (*asẹberia*) representing the deceased king in full ceremonial regalia, surrounded by his main courtiers and chiefs. He wears the coral bead outfit used only at Iguẹ and Ugie Erha Ọba, the two main ceremonies of divine kingship. In one hand he holds a ceremonial sword, *ẹbẹn*, and in the other a proclamation staff (*isẹvberigho*) in the form of a gong (*ẹgogo*). The small leopards on the sides represent large cast or carved leopards actually placed alongside the king in ceremonies (fig. 70) and refer to the tamed leopards that once accompanied the king when he paraded in the city.

The Divine King

The ancestral altars are the major shrines in the palace. A king may have personal shrines to Olokun, his Hand, and so on, and there are a few royal gods, such as Uwẹn and Ọra, but the altars honouring his ancestors are the main ones which are completely national in scope. The living monarch rules by virtue of being descended from Oranmiyan, the founder of this dynasty, and thus he is the caretaker of these shrines for the benefit of the Benin people. The king, like the commoner, officiates at the royal altars to request the aid of his ancestors, but, unlike the commoner, his predecessors are the protectors of the nation at large and their own divine power has passed on to him. While the divinity of the Ọba indeed derives from his descent, it has wider moral implications. As the reigning monarch, he alone possesses the royal coral beads. Since other members of his immediate family can claim similar descent, possession of the beads and other royal relics determines who ultimately sits on the throne. This is made clear by the story related earlier about the conflict between the sixteenth-century king Ẹsigie and his brother Arhuaran, who battled for possession of a special coral bead. The royal coral beads are not merely ornamental; they have the power of *asẹ*, that is, whatever is said with them will come to pass. The ability to curse and issue proclamations is one of the principal sanctions of the monarchy. As the late Chief Ihaza explained: 'The Ọba does not use Ẹsigie's bead now because

73 Figure of an Ọba in ceremonial dress. This type of figure was placed on an ancestral altar, the loop above, according to Chief Ihama, enabling its easy removal for polishing (pc1981). In his right hand, the Ọba holds an *ẹbẹn*, a ceremonial sword with which he dances to honour his ancestors. In his left hand is a proclamation staff, *isẹvbere igho*, in the form of a gong, *ẹgogo*. There are both ivory and brass gongs. Some are used as proclamation staffs and others, particularly the ivory ones, to drive away evil forces in the Emobo ritual (see figs 90, 91). H. 68cm.

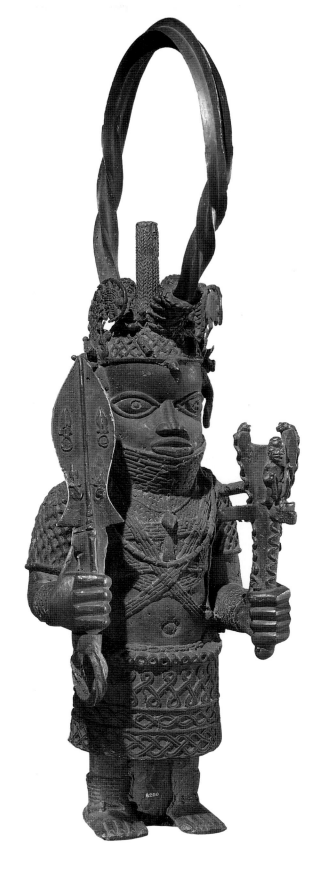

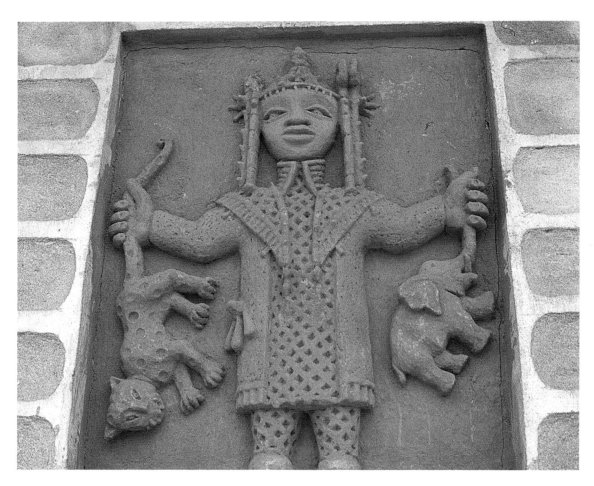

74 Terracotta plaque on the face of the palace. A series of these plaques, depicting famous Ọbas, warriors and magicians, was commissioned by Ọba Akẹnzua II from Ọvia Idah. This plaque represents the coronation of Akẹnzua II, when he sacrificed a leopard and an elephant.

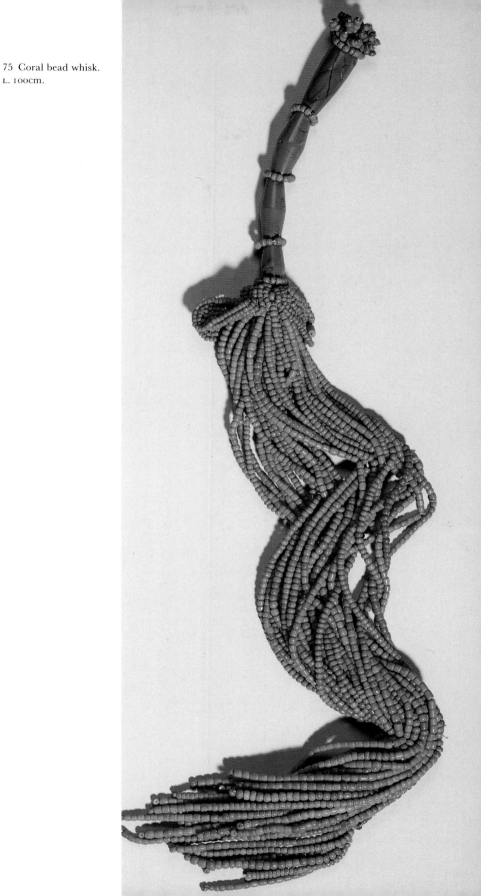

75 Coral bead whisk.
L. 100cm.

According to Bradbury (1973), special groups of buyers, Idẹmwin, from the Ibiwe palace society, used to collect animals for sacrifice from villages. These brass swords were their staffs of office.

he does not swear or curse. If he swears or curses it would be impossible to revoke. Whatever he says will have effect.' The coral beads are not the only sources of the Ọba's power to curse: the proclamation staff, *isẹvbere igho*, gives him the same power (fig. 73) but the beads are probably more important for they define the monarchy and provide its mystical sanction. According to Chief Ihaza: 'When the king is wearing this heavy beaded costume, he does not shake or blink but stays still and unmoving. As soon as he sits down on the throne he is not a human being but a god' (pc1981).

The Ọba was perhaps most godlike in one attribute: he alone had the right to take human life. In the court of law he was the final arbiter of the death penalty, while in the course of ritual he alone offered human sacrifices (although a few of his most powerful chiefs were granted the same privilege). Thus 'attitudes towards the kingship were a complex of affection and awe, pride, and fear, but the overriding notion . . . was one of fearfulness'.[13]

The position of the Ọba stems also from his cosmological status. As king of the dry land he is the counterpart of Olokun, king of the great waters. The wealth and power of the Ọba traces back to the time when Ọba Ẹwuare went to the river and brought back the coral beads and other riches from Olokun's kingdom. Just as Olokun's palace is a source of beauty, wealth and fecundity, so also is its earthly counterpart, the palace of the king of the dry land.

Art and Ritual in the Palace

The royal palace was considered the centre of the Benin world, and it is evident from travellers' reports how extensive and impressive a structure it was. Of far greater size and complexity than the compound of even the richest chief, it was also more highly decorated. In the accounts of members of the British Expedition we learn that the doors, lintels and rafters of the council chamber and king's residence were lined with sheets of repoussé decorated brass covered with royal geometric designs and figures of men and leopards. Ornamental ivory locks sealed the doors and carved ivory figurines surmounted anterior posts. A brass snake, observed for the first time by a European in the early eighteenth century, was still to be seen on the roof of the council chamber house.[14] As we mentioned earlier, the palace has been rebuilt, although it is much reduced in size and splendour. Where once compounds existed for all the former kings, now only one large walled area encloses individual altars for each of the four immediate predecessors and one general altar for all the rest. Decorated sheets of brass, however, still adorn the rafters and lintels, and terracotta plaques

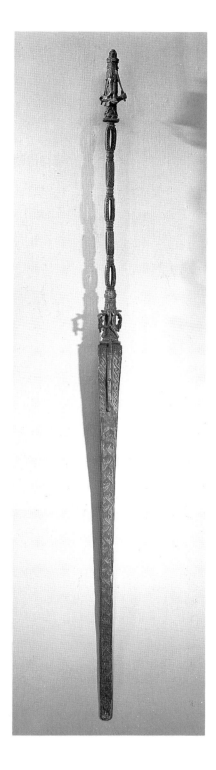

now recount the exploits of former kings (fig. 74).

The palace was, and still is to a certain extent, the focal point of Benin social aspirations. The accumulation of wealth is an avenue to high status, particularly when utilised in the purchase of a chiefly title in the palace. Each title is a political office but also a ritual responsibility. Indeed, most chiefs define their roles in terms of their ritual duties to the king.

The palace is the centre of ritual activity aimed at the well-being and prosperity of the Benin nation. Over and above domestic, guild or village religious ceremonies, there is an annual cycle of rituals held within the confines of the palace.[15] Some are of a private nature, such as the Oba's sacrifices to his own *ẹhi*, Ugie Ama, or to his Hand, Ihiekhu. Others, to be described here, are public. In recent times, the number of public rituals performed has been reduced and their performance restricted to the Christmas vacation. These rituals draw upon a wide range of participants and demand enormous amounts of time and energy. Materials for use in the ceremonies, such as animals to be sacrificed or foodstuffs for offerings and gifts, come in from around the kingdom (fig. 76). Some villages send groups of specialists to perform in specific ceremonies, such as the Ilobi villagers from Isi, who are specialists in the preparation of poisoned arrows and come to participate in the Isiokuo mock war. Within the capital city, whole guilds are organised around their participation in ceremonies, among them drummers, shield-bearers, ritual slaughterers and distributors of sacrificial animals. Craftsmen of all kinds, carvers, casters, weavers, leatherworkers and so on, provide regalia and ritual objects to be used in the ceremonies, while a vast number of Osun specialists work out intricate magical preparations (fig. 87). The various chiefly orders, the craftsmen, Osun specialists and others all have work and storage areas within the palace. It is a hive of activity; the Ẹdo in fact draw the very apt parallel between the palace and the complex hierarchical organisation and bustling activity of a large termite mound.

The king himself and his many chiefs have much to do to prepare themselves materially and spiritually for the ceremonies. Regalia must be made to order or refurbished, protective charms must be prepared and sacrifices performed to ensure success. In the Benin simile, 'going to a palace ceremony is like going to war'. Danger lurks from enemies of the king both within and outside the kingdom and one of the important duties of the chiefs is to provide magical protection to augment the great mystical power of the Oba himself (see figs 78, 81).

77 Brass plaque of two chiefs in 'pangolin' costumes. As comparison with fig. 78 demonstrates, there has been some continuity in ritual attire over time. H. 46.5cm.

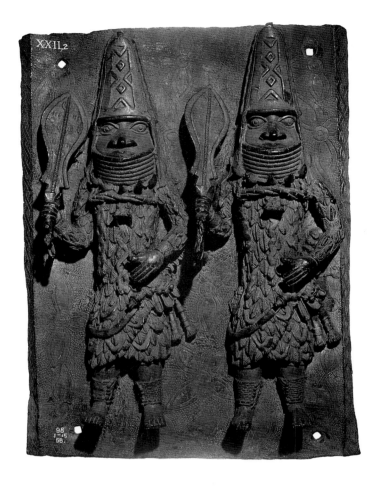

78 OPPOSITE High ranking Town Chiefs dress in an elaborate costume called 'pangolin skin'. Although now made of imported red flannel, the material is cut in such a way as to imitate the scales of the pangolin, or scaly anteater, an animal which curls up when in danger and thus becomes invulnerable. The association of pangolins with Town Chiefs, traditionally sources of opposition to the Ọba, is apt since it is said that 'the pangolin is the only animal the leopard cannot kill'.

In former times, one chief, the Aragwa, was responsible for determining the dates of royal rituals through keeping track of the agricultural seasons and co-ordinating them with the specific days of the four-day Benin week considered appropriate for palace ceremonies. The yearly round of rituals is grounded in the agricultural cycle – indeed it opens and closes with agricultural rites – but the ceremonies are primarily concerned with the purification and strengthening of the kingdom. Although not all are still performed, they will be described here in the order and form they once had.

The festival of Ikhurhẹ opens the cycle. It takes place during the season of 'brushing the farm', that is, the period of preparation for planting when the ground is cleared and great trees are felled in the forest. This is approximately early March in our calendar. The

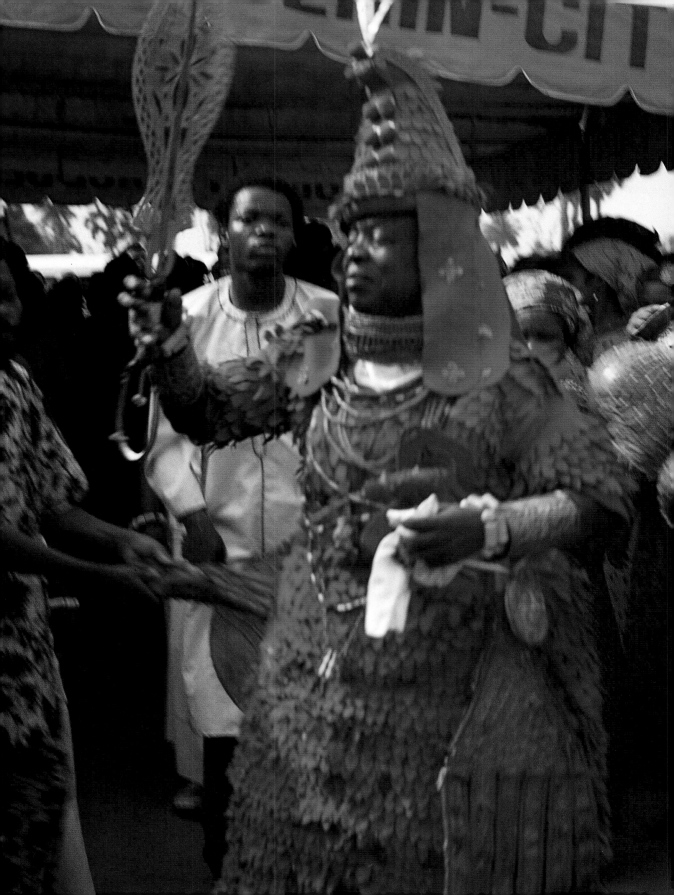

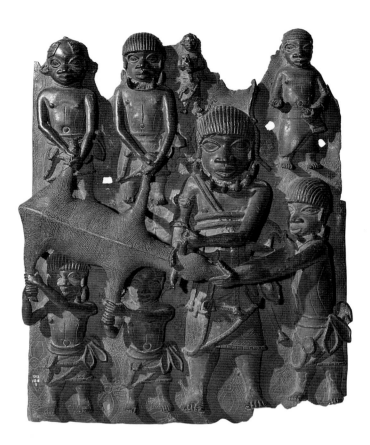

79 Brass plaque of cow sacrifice. Sacrifice is the focal point of nearly all Benin rituals. In pre-colonial times the king used to sacrifice enormous numbers of animals, cattle being the highest form of domestic beast offered. H. 51cm.

purpose of Ikhurhẹ is to purify the land and ensure fertility for the crops soon to be planted. In every home, offerings of snails and other 'cooling' materials are placed at the foot of the primordial *ikhinmwi* tree, the shrine of the land, while various guilds perform a general purification for the land of the nation as a whole. Without the 'cooling' or ritual purification of the soil, no other palace event could take place.

Ikhurhẹ is followed by the Bead Festival (Ugie Ivie) and Ọrọ Festival (Ugie Ọrọ), both created by the sixteenth-century king Ẹsigie in remembrance of his great internal and external wars. Ugie Ivie recalls the struggle between Ẹsigie and his brother Arhuaran of Udo over possession of the royal coral bead, which would be used to proclaim the capital of the kingdom. During the ceremony, all the beads of the kings, chiefs and royal wives are gathered together on the palace altar in honour of Ọba Ẹwuare, who first brought coral beads to Benin from the palace of Olokun, and the blood of a human sacrifice is poured over them (nowadays a cow is used).

This blood gives mystical power to the beads and fortifies them for all following ceremonies (fig. 75). Thus, while Ikhurhẹ prepares and purifies the land of the kingdom at large, Ugie Ivie augments the power of the royal relics, the core of the monarchy. Ugie Ọrọ follows. Every five days for the next three months, the king and chiefs dance in procession, outdoing each other in lavishness of dress. It is considered so attractive a festival that, in the Benin adage, 'If a farmer participates in dancing Ọrọ he will never take care of his farm'. As part of the ceremony, chiefs dance in a circle, beating with a rod the beak of a cast brass bird in remembrance of the prophetic bird Ọba Ẹsigie had killed on his way to success against the Igala people (figs 82, 21). This commemorative element appears to have been grafted by Ẹsigie on a basically ancestral rite started by an earlier king, Ọba Ẹwẹdọ, since throughout the period sacrifices are made to the royal ancestors, a foreshadowing of the main ancestral rites to come.

Ọba Ẹsigie is said to have introduced the next two ceremonies as well, but with them the pendulum swings back from royal

80 Brass hip ornaments (*uhunmwun-ekhue*). Chiefs of all ranks wear a brass mask-shaped pendant on the left hip when dressed in full ceremonial regalia. In form it is related to the brass pendants sent to vassal rulers (fig. 19) and the ivory pendant worn at the waist by the Ọba (fig. 94). H. 94cm.

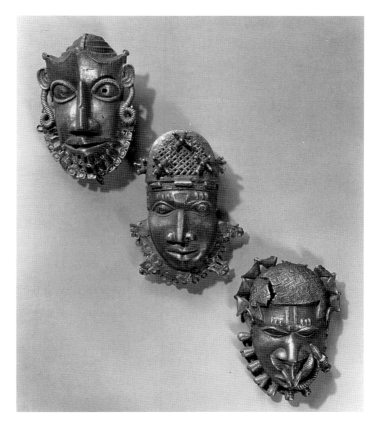

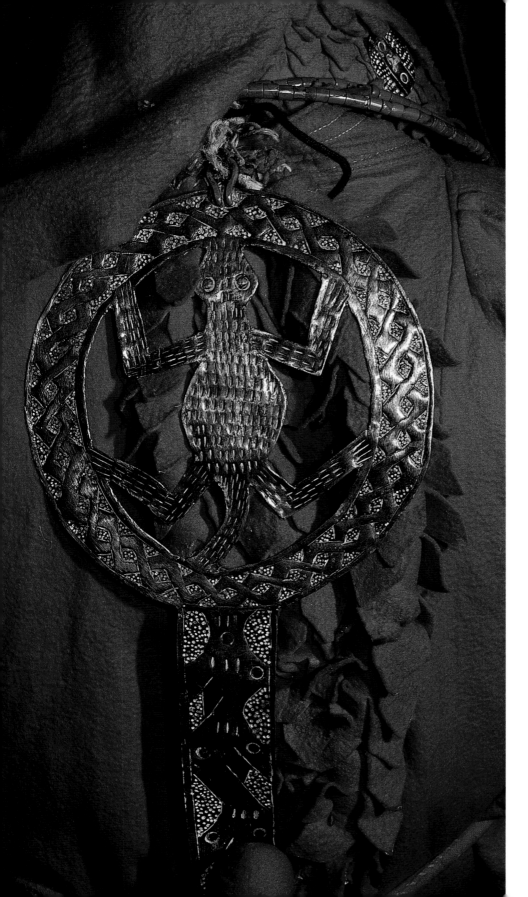

81 The brass ornament hanging down the back of the chiefly 'pangolin skin' outfit is called 'scorpion'. According to Chief Eghobamiẹn, 'the brass scorpion worn . . . by chiefs on their back is to indicate that the chief is as dangerous as a scorpion . . . In the olden days it was dangerous for a chief to be coming and going in town. So he used to equip himself with such a charm'. (pc1976)

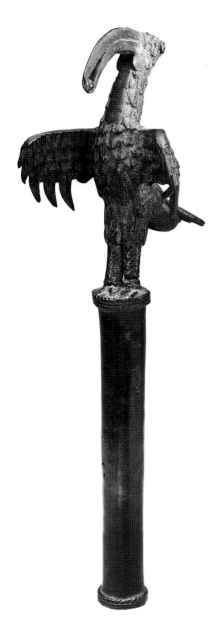

82 Brass staff (*ahianmwẹn-ọrọ*). At Ugie Ọrọ chiefs carry this staff and hit the beak with a brass rod in remembrance of its ignominious prophecy. H. 33cm.

commemoration to general purification. The ritual of Ẹghute is aimed at the fertility of the nation, specifically formulated as an effort to prevent miscarriage and birth fatalities. All pregnant women are sent outside the city limits for the duration of the rites in order to protect them from the frightening secret activities. At the time of Ẹghute, 'messengers are sent to Prince Arhuaran's gardens at Udo for a herb with which to make medicine that will cause corn and yam to fructify the same day as planted'.[16] Reiterating this theme, a chief (the title-holder Osuan), dressed as a pregnant woman, is said to conceive and deliver by magic on the same day. At night he goes to the cemetery on Ikpoba Hill, a place where witches congregate, and casts off his clothing, thus driving off the evil spirits that bring premature delivery and maternal death. Following Ẹghute, the Orhu festival is similarly supposed to repel evil. The high point of Orhu is the preparation by the Ọba's mother of a feast of pounded yam and soup without oil, which is taken by the palace group Irho-Ema and placed at all nine gates to the city as an offering to keep away evil forces. These gates are considered to be crossroads, and all crossroads are viewed by the Ẹdo as the meeting point of the spirit world and the world of everyday life, and so are the focus of offerings made to potentially harmful spirits. Orhu is said to have been introduced by Ọba Ẹsigie to commemorate a feast prepared by his mother Queen Idia before he left for the Udo war.

All of these rituals build up towards the two most important rites of the year: Ugie Erha Ọba, which honours the king's deceased father, and Iguẹ which strengthens his own mystical powers. Both ceremonies are said to have been instituted by Ọba Ẹwuare. Ugie Erha Ọba and Iguẹ are paired conceptually in that both are of paramount importance and have a tripartite structure. They differ, as Ọba Akẹnzua II himself pointed out, in that in Ugie Erha Ọba the king is the officiator while in Iguẹ he is the object.[17] Ugie Erha Ọba is the culmination of a series of ancestral rites. As a prelude, all families in Benin celebrate Ehọ for their own paternal ancestors. This general service is followed by palace rites (Ugie Igun) honouring each former king individually, ending at Ugie Erha Ọba with the immediate predecessor of the present king. The ritual is full of the symbolism of royal supremacy. It opens with the Greeting Ceremony, Otuẹ, in which the Ọba, seated before his father's altar, accepts the homage of the chiefs, as one by one in order of seniority they come to greet him, and in return, he makes them gifts of kola nuts and wine (see fig. 2). Their acceptance of these gifts, indeed their very participation in the ceremony, is an acknowledgement of the hierarchical political structure and the supremacy of the king.

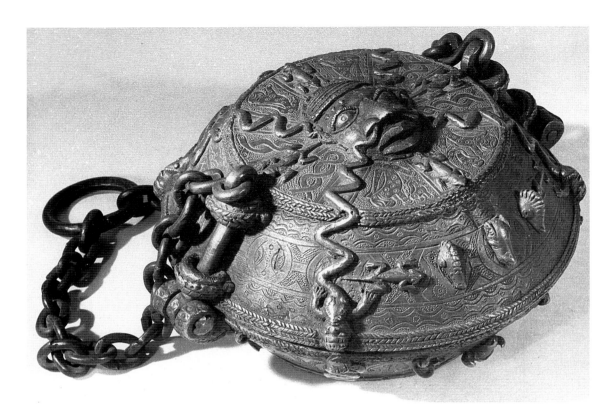

83 Decorated vessel (*igie*). According to Bradbury (1973), at Ugie Erha Ọba the king taps the lid four times, accompanied by the prayer that he will sit firmly on the throne. H. 12cm.

The main ceremony of Ugie Erha Ọba is a lavish affair. Chiefs wear their most expensive costumes and dance with a ceremonial sword, *ẹbẹn*, each trying to outdo the others in elegance and grace. The king wears his most elaborate beaded outfit and he, too, dances with an *ẹbẹn* – the highlight of the ceremony – before his father's altar. Many sacrifices are offered to avert evil spirits, to appease the earth and, especially, to honour and propitiate the Ọba's late father. On the third day a mock war, Irọn, is staged against the Seven Uzama who are vanquished by the supporters of the king, just as all other foes during the year to come will be vanquished.

Iguẹ is also divided into three parts, beginning with a Greeting Ceremony, but its focus is more on a spiritual level. The main rite, Iguẹ itself, centres on the Ọba's mystical powers. Roots, herbs and seeds, the 'life-giving products of the forest', are made into a magical potion that is applied to the different parts of the Ọba's body by Ogiefa, the priest responsible for the purification of the earth, and the Ihama of Ihogbe, the representative of the Ọba's family. All the animals of royal symbolic significance – the leopard,

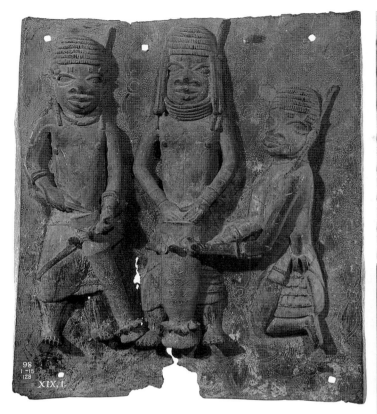

84 Brass plaque depicting members of the Ikpe-iwini subsection of Ogbelaka guild. This guild has important duties at the investiture of chiefs and in palace rituals. The Ikpe-iwini subsection play the drums and the Eneha sing songs in a secret language, unknown even to other guild subsections. H. 44.5cm.

85 Ogbelaka drum in the Ọba's palace, photographed in 1970.

king of the bush animals, the vulturine fish eagle, king of the day birds, as well as the usual cows and goats – are sacrificed to the Ọba's Head, the locus of his wisdom and capacity to succeed. 'With the Ọba's well-being is identified the well-being of the nation and by this rite . . . the welfare of the Ọba and his people is ensured for another year.'[18]

On the last day, children rush from their homes early in the morning carrying torches to drive away evil spirits. Once outside the town they gather up ẹwẹrẹ leaves, called 'leaves of joy' and bring them home as signs of hope and happiness. In a similar vein, chiefs bring ẹwẹrẹ leaves to the palace as a sign that Iguẹ has gone well and that the Ọba and his people will prosper in the coming year.

Once the Ọba's powers have been fortified, he utilises them in

The Art of Benin

86 Leopard aquamanile. According to Bradbury (1958), after the Ǫba finishes dressing and preparing himself for Ugie Erha Ǫba, he washes his hands with water from this aquamanile. When not used in ceremonies, it rests on Ǫba Ẹwuare's altar. H. 30.5cm.

87 An *ǫbo* (Osun specialist) at a palace ritual. Compare his headgear with the Ekpo representation in fig. 59. Osun specialists are crucial to the success of these rituals.

ceremonies to purify and strengthen the nation. The festival of Emobo follows Iguẹ. It differs from earlier rites in that there are no sacrifices, elaborate chiefly dances or ceremonial appearances by the Ọba's wives and children. Its sole purpose is to drive away any evil forces that have somehow remained despite the previous ceremonies. To this end, the Ọba sits in a specially constructed pavilion made of red cloth, red being a 'threatening' colour with the capacity to drive away evil. Later he dances with an ivory gong, striking it to repel malevolent spirits (figs 90, 91). The ritual ends with Chief Esọgban calling out: 'Any spirits that have not received offerings should go to Udo and eat', thus driving the last remnants of evil to the ancient rival town of Udo.

The simile that 'going to a palace ceremony is like going to war' is

88 and 89 As Iguẹ draws to an end, the Uwanguẹ brings the Ọba a ceremonial box (ẹkpokin) with gifts from the King of Ife. This type of box, shown both in the photograph and in the plaque, was made by the leather workers' guild (and sometimes covered with brass sheeting). H. of plaque 54cm.

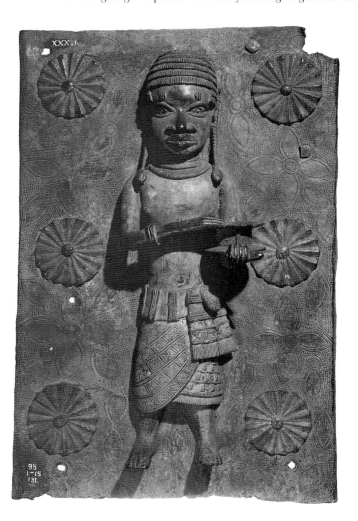

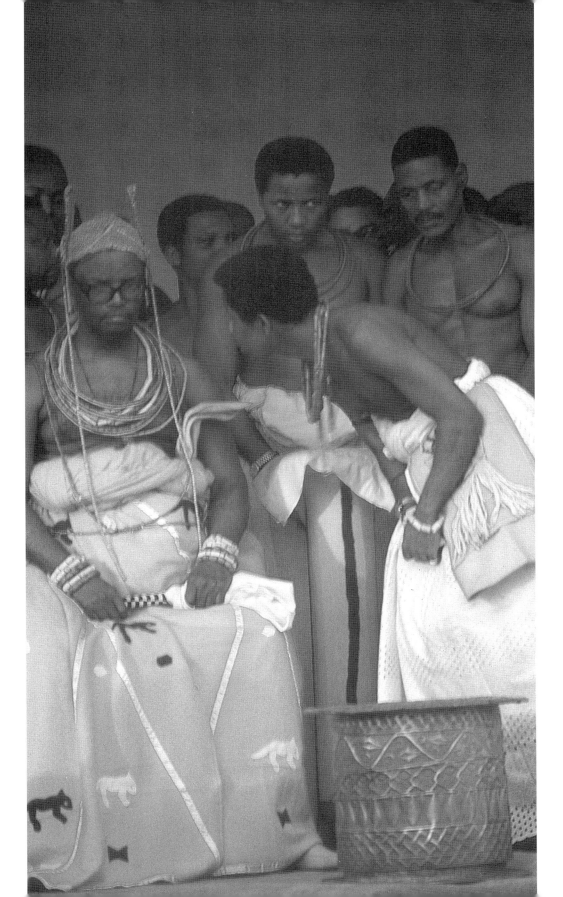

90 Ọba Erediauwa at Emobo 1981.

91 Ivory gong. The Ọba strikes an ivory gong to drive away evil forces. Similar rituals are carried out in villages when supernatural danger threatens. There, however, iron gongs are used. The royal gong is made of ivory, white being a symbol of ritual purity, and has carved designs of crocodiles, mudfish, water tortoises and snakes – all drawn from Olokun's pure and perfect world. The predominance of allusions to ritual purity reflects the ideal state to which Emobo aspires. H 36cm.

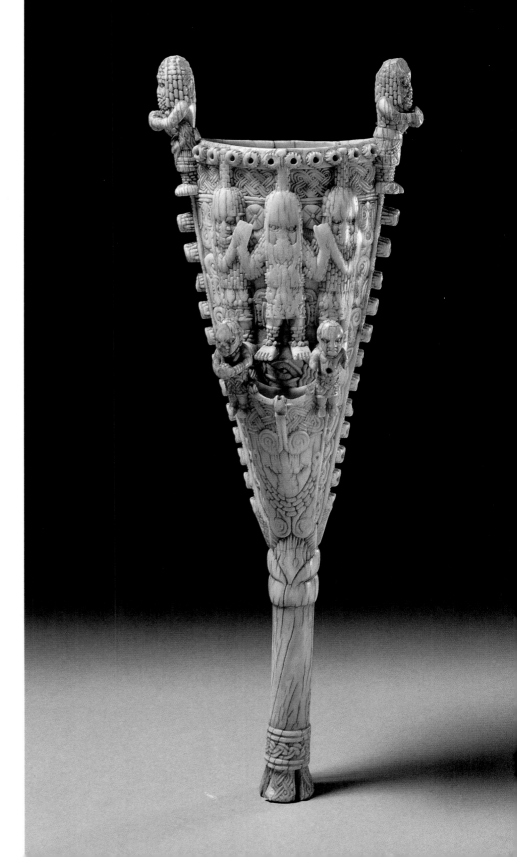

92 This brass plaque depicts the ceremonial official Ọton. According to Bradbury, at Ugie Erha Ọba and Iguẹ, members of Ọton carry whips with which they lash the air to drive away evil spirits. Under their robes they wear the jaw bones of deceased Town Chiefs. When a Town Chief died, the Ọba claimed his lower jaw, 'the jaw he used to dispute with the Ọba', symbolising the ultimate supremacy of the king over his people. H. 45.5cm.

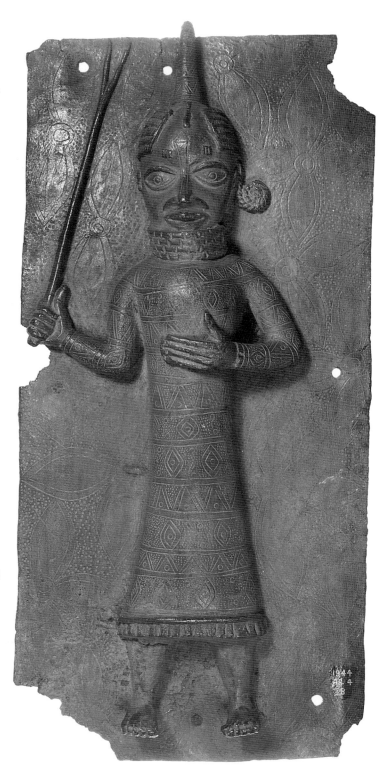

93 OPPOSITE A plaque of a chief wearing the ceremonial war dress (*akpa*) for Isiokuo. Around his neck hangs a bell for protection and signalling. The face of the leopard decorating the cloth is to strike fear into the hearts of the enemy (see fig. 96). The leopards' teeth necklace has a similar protective meaning. A red parrot feather in his headdress assures him of success and a horsetail hanging down the side is a mark of prestige. In one hand he holds a spear (*ọgala*) and in the other a shield (*asa*). Accompanying him are two horn players. H. 56.5cm.

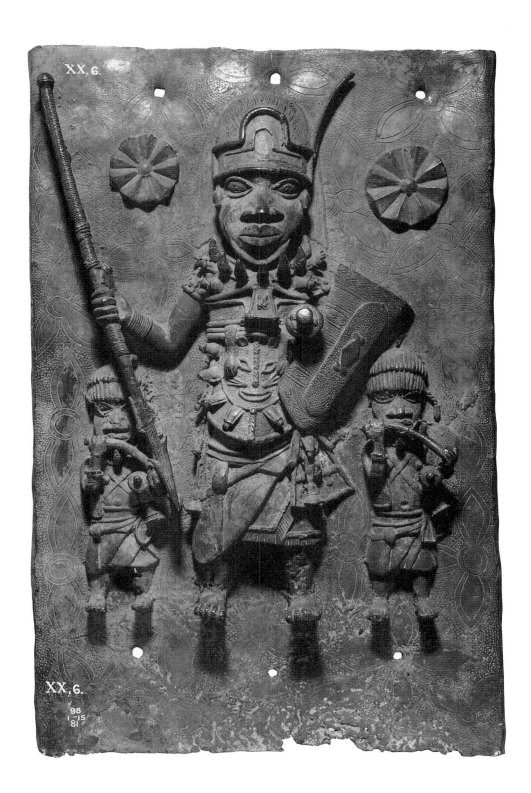

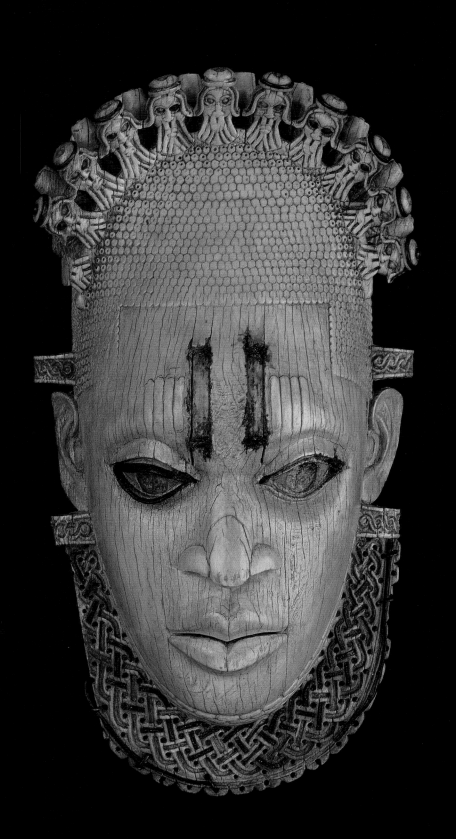

94 Ivory waist pendant worn by the Ọba as part of his costume for the commemorative rites for his deceased mother (Ugie Iyọba) and for the Emobo ritual. The late Ọba Akẹnzua II identified this mask as representing Idia, the mother of Ọba Ẹsigie, because of the Portuguese heads around the top. Ẹsigie is said to have been the Ọba reigning when the Portuguese first arrived in Benin. H. 25cm.

95 OPPOSITE Elaborately carved ivory bracelets such as this one were the prerogative of the Ọba. According to Chief Ovbiebo of the Enisen section of the Iwebo palace society (the group assigned the selection and coordination of the Ọba's ceremonial wardrobe) ivory bracelets are worn especially in ceremonies in which the Ọba dances with an ẹbẹn and handles a gong, because the bracelets keep his coral beads from getting tangled (pc1981). Ekpo Eyo has argued that this bracelet was made by an Owo Yoruba carver (pc1984). H. 13cm.

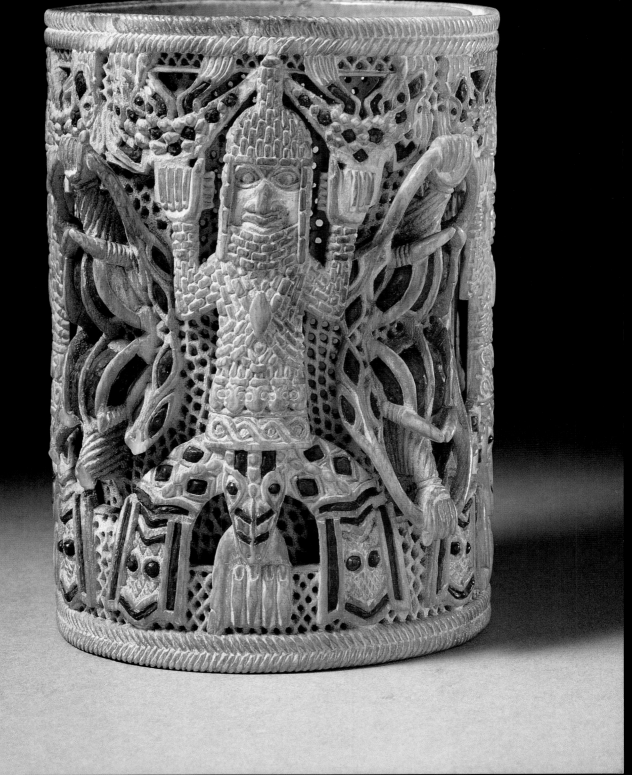

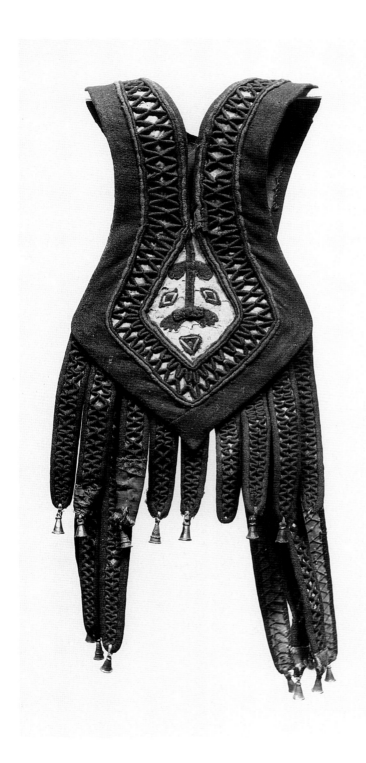

96 Warrior's tunic with embroidered leopard's face.

97 OPPOSITE Ivory staff of a horseman wearing a warrior's bell around his chest and a headdress surmounted by a horsetail. This type of staff may have been held by high-ranking chiefs in the Ugie Ọrọ ceremony, according to Blackmun (pc1994). H. 39cm.

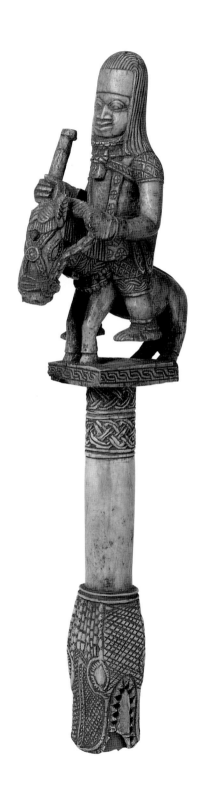

almost literally true in Isiokuo, a ceremony in honour of Ogun, god of iron and of war (fig. 84). Dressed in military regalia, the Ọba and chiefs parade from the palace to the shrine of the god of war and there watch the Amufi acrobats display their skills in the high cotton tree, whirling and turning in what is described as a war against the sky.

The yearly cycle ends as it began, with an agricultural rite, but one with wider implications. From the start of the New Yam Festival, Aguẹ, until it is over, it is forbidden to consume or offer to the gods newly harvested yams. Aguẹ is held in extreme secrecy within a special room in the palace and only the Ọba and a few members of Ogbelaka guild know what happens inside (fig. 84). Ọba Eresọyẹn added a subsidiary festival to Aguẹ called Aguẹ Ọsa (Aguẹ of the Supreme God). Aguẹ Ọsa honours the progenitor of the royal lineage, Ododua, the father of Oranmiyan. The officiators are the chiefly title-holders Ọsa and Osuan, the caretakers of the royal gods Uwẹn and his wife Ọra who are said to have come from Ife with Oranmiyan. The dance of Ododua is performed by seven masqueraders who wear brass helmet masks and hold ceremonial swords. They dance back and forth before the Ọba seven times, a sign of their loyalty and commitment to his protection (figs 98–100).

With Aguẹ, the cycle has come full circle. All that has been harvested during the year may be consumed, evil forces have repeatedly been driven from the land, and the Ọba is strengthened and ritually fortified for the coming year. As the Ẹdo say, 'Everything is cool'.

In spite of the recent intensification of Christian worship in Benin, the Ẹdo religion continues to flourish. Ọba Erediauwa is a staunch supporter of Ẹdo traditions and has revived and revitalised the court rituals and arts. Benin art has shown over the centuries a remarkable resilience in the face of all kinds of change, whether political, economic, social or religious. Today established forms, such as mud shrine figures and ancestral altar furnishings, continue to be made, and new forms are emerging to become an integral part of modern Benin culture.

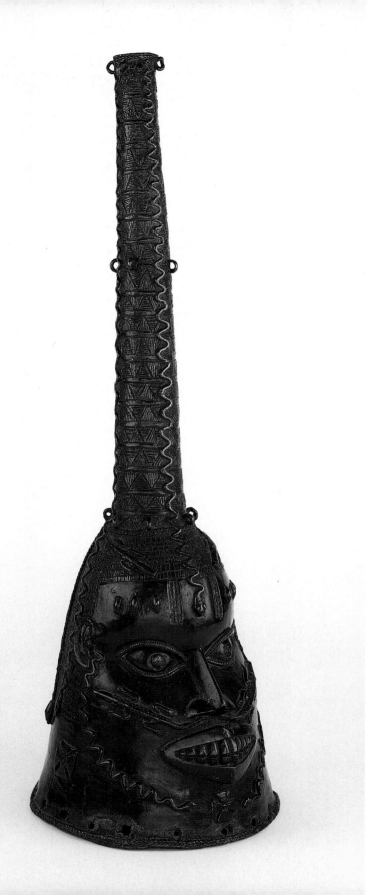

98 & 99 Brass helmet masks for Ododua ritual, the one on the left representing a male and the one on the right a female. H. 56cm, 35.7cm.

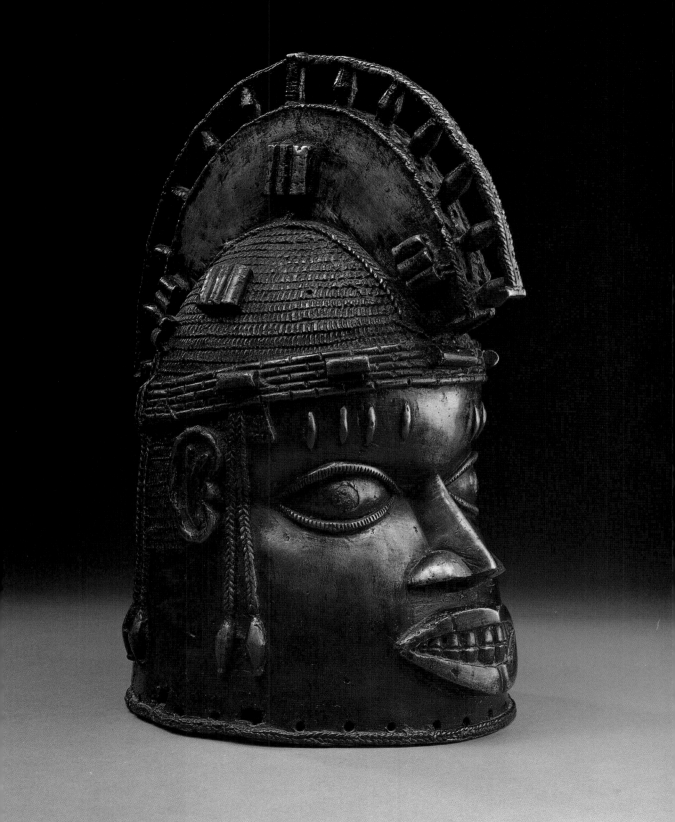

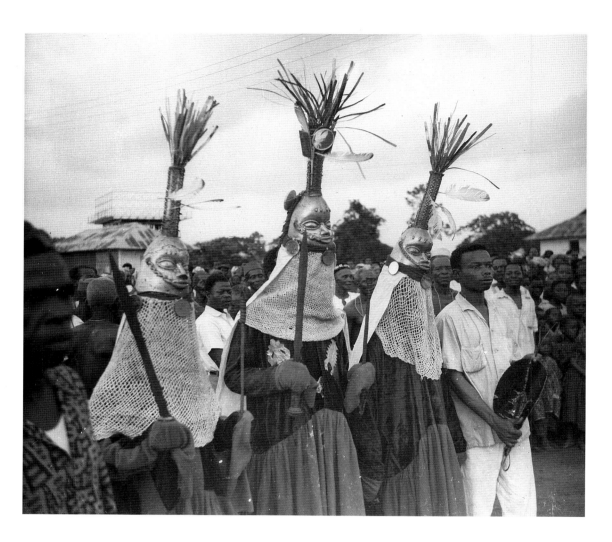

100 Three male masked dancers at
Ododua in the 1950s.

NOTES

Introduction

1 This figure is based on Ikhuorhia's estimate of the population of Benin City in 1980 at 425,000 with a growth rate then of 8.6% p.a. (1984:177).

2 Connah 1975(a), p. 32; Obayemi 1976, pp. 241–5; Shaw 1978, pp. 167–9. See Andah (1982) for a critical review of the literature on early Benin urbanisation.

3 Translated by Hodgkin 1960, p. 93.

4 Ẹdo spellings in this book are based wherever possible on Agheyisi 1986 and Melzian 1937.

5 This legendary figure is called Aranmiyan in Ẹdo and Oranyan or Oranmiyan in various Yoruba traditions. I have utilised the latter because it is the version most commonly found in the scholarship on the area. The exact ethnic origin of Oranmiyan is a subject of current debate in Benin. Many Ẹdo, including Ọba Erediauwa, argue that Oranmiyan was the son of the last Ogiso, called back from exile in Ife.

6 Boston 1969, pp. 29–43.

7 Translated by Hodgkin 1960, pp. 100–101.

8 Bradbury 1973, pp. 44–75, is the basis for much of the discussion of political and social organisation (as well as the king list on page 21). However, Bradbury tended to assume that the overall structure of the Benin government had not changed substantially over time. Ben-Amos and Thornton n.d. examine the problems with this assumption as regards the seventeenth and eighteenth centuries.

9 See Ben-Amos 1986.

10 For references for the period until the late 1960s, see Ben-Amos 1968 and Ombu 1975. Stylistic chronologies for the brass sculpture have been developed by von Luschan 1919, Struck 1923, Fagg 1963, Dark 1975, and Williams 1974. Blackmun has developed a chronology for the ivory tusks (1984a). Metallurgical analysis has been applied to the brasses: see Goucher 1978, Werner 1970, Werner and Willett 1975, Willett, Torsney and Ritchie 1994. For a critique of metallurgical analyses see Craddock and Picton 1986. Thermoluminescent dates can be found in Willett and Fleming 1976.

11 The information that I collected is based on four field trips to Benin between the years of 1966–81. My own work builds on the scholarship of the late anthropologist R.E. Bradbury, who spent many years there. Besides Bradbury, the anthropologists Justine Cordwell and Philip Dark, and the museum ethnographer William Fagg also did research in Benin, primarily in the 1950s. In the 1980s and 1990s, the art historians Barbara Blackmun, Kathy Curnow-Nasara and Alfred Izevbigie, and the anthropologists Joseph Nevadomsky and Flora Kaplan, among others, have conducted fieldwork on Benin art.

12 Andreas Josua Ulsheimer, 'The First Voyage to Africa, as far as Rio Benin, etc' in 1604–5, trans. Jones 1983, p. 42. Another example of change is suggested by Blackmun 1988, who traces the transformation of an image in Benin carving over several centuries.

Art, History and Politics

1 Although colonial anthropologists recorded oral histories, it was primarily Chief Jacob U. Egharevba who compiled and organised the most widely known history of Benin (1968), first published in 1934. His representation of Benin history has influenced scholarship on Benin art and has also fed back into Ẹdo oral traditions and had an impact on local formulations of their past.

2 Egharevba 1968, p. 3; Dike 1959, pp. 12–14; Talbot 1969 [1926], p. 153.

3 Bradbury (1973: 17–43) discusses and evaluates the different chronologies.

4 Ben-Amos 1978, p. 49; Dark 1973, pp.53,56,64; Egharevba 1968, pp. 1,10.

5 Egharevba 1968, p. 10.

6 Egharevba 1968, p. 1.

7 Bradbury 1951, A-18; Marshall 1939, p. 9; Read and Dalton 1899, p. 6.

8 Egharevba 1968, p. 11.

9 Bradbury 1951, A-18.

10 Connah 1975(b), pp. 142–3 and Garrard 1983, pp. 17–18.

11 Connah 1975(b), p. 147; Herbert 1973, pp. 180–2; Shaw 1978, pp. 118–19.

12 Connah 1975(b), p. 147; Werner 1970; Shaw 1965.

13 Connah 1975(b), pp. 34,57; Johnson 1970, pp. 17–18; Garlake 1974, p. 125; Willett 1980, personal communication.

14 Bradbury 1957, p. 21.

15 Alagoa 1976, p. 371; Henderson 1972, pp. 43–6; Obayemi 1976, pp. 252–3.

16 This description of pre-Columbian Mexican art by Richard Townsend (1979, p. 12) can be applied as well to the art of Benin in the fifteenth and sixteenth centuries.

17 Fraser 1968, pp. 44–5.

18 Bradbury 1973, p. 139.

19 Ryder 1969, p. 11.

20 Shaw 1978, pp. 171–2.

21 Discussion of the Portuguese period is based on Ryder 1969, pp. 24–75.

22 Bassani and Fagg 1988; Curnow 1983; Fagg 1959; Ryder 1979. Eisenhofer (1994) has recently argued against the Edo origin of these ivories.

23 Read and Dalton 1899, p. 6.

24 Dark 1973, p. 4; Fagg 1963, p. 33; Sieber 1979, personal communication.

25 Connah 1975(a), p. 4.

26 Dark 1973, p. 73.

27 Translated in Jones 1983, p. 42.

28 Translated in Roth 1968, p. 74.

29 Van Nyandael 1705, p. 534 (trans. A. van Dantig, 1978, personal communication).

30 Dark 1960, p. 21; Fagg 1963, p. 33.

31 See Ben-Amos 1983(c) and 1984 for discussions of this period.

32 Jungwirth 1968, p. 204.

33 Based on the Capuchin report 'A Short Account of the Things That Happened During the Recent Mission to Benin 1651–52' in Ryder 1969, p. 314.

34 Landolphe 1823, p. 98.

35 Ryder 1969, p. 144.

36 See various publications by Barbara Blackmun.

37 Ryder 1969, p. 20.

38 Allman 1898, p. 44.

39 Van Nyandael 1705, p. 535. See Roth 1968, Ch. xvii for visitors' descriptions.

40 *Royal Gold Coast Gazette*, Vol. I, No. 21, 25 March 1823.

41 F.N. Roth quoted in Roth 1968, p. 175.

42 Burton 1863, p. 279. It is interesting to note that both Ulsheimer in 1603–4 and Burton in 1863 saw carvings representing human heads, while others saw animals. Thus, Fagg's contention that Oba Osemwede (1816–48) first allowed chiefs to switch from animal to human heads (1963, pl. 15) may not hold up in the light of visitors' evidence.

43 Connah's excavations (1975b:177–9) revealed a large quantity of imports. For discussions of the artistic imagery of Omada carving see Ben-Amos 1975, 1983(b) and Hess 1983: 41–8. For the identification of Ozolua see Blackmun 1983: 49–50 and 1990: 64–5.

44 Ryder 1969, p. 259.

45 Cordwell 1952, p. 168.

46 For a discussion of this period see Cordwell 1959, pp. 47–8 and Ben-Amos 1971.

47 Dickerson 1979, p. 37.

48 Kelly and Stanley 1993, p. 234.

49 Kelly and Stanley 1993, pp. 190–92.

50 Barbara Blackmun 1994, personal communication. I am very grateful to her for information regarding the dating and iconography of the ivory tusks.

51 Nevadomsky 1992, p. 11.

52 There is some work now being done on new artists, for example, see Betty LaDuke on Princess Olowo 1988. For references for modern artists see Kelly and Stanley 1993.

Art, Belief and Ritual

1 Lopasic 1965, p. 101; Izevbegie 1978.

2 See Beier 1963; Ben-Amos 1973, 1986, 1994; Izevbigie 1978; Rosen 1989, 1993.

3 Bradbury 1957, p.53.

4 Izevbigie (1978) documents these village shrines.

5 Murray 1960.

6 For Ogun in Yoruba and Benin history see Barnes and Ben-Amos 1989.

7 Nevadomsky 1988, p. 78.

8 Ben-Amos and Omoregie 1969; Lopasic 1965.

9 For a recent discussion of Edo concepts of the Head, the Hand, and other aspects of human personality, see Babatunde 1992.

10 Babatunde 1992, p. 146.

11 See Ben-Amos 1983(a), Nevadomsky 1987 and Kaplan 1993.

12 Blackmun 1984, p. 31.

13 Bradbury 1973, p. 75.

14 Roth 1968, pp. 171–7; Dark 1973, p. 54, nos. 111–14.

15 Discussion of the annual ritual cycle is based on my field notes for 1975/76 and 1981, Bradbury's field notes on file at the University of Birmingham, and the files of the Edo (formerly Bendel) Arts Council. More recently, Nevadomsky and Inneh (1983) and Nevadomsky (1984) have described the rituals of coronation.

16 Egharevba 1949, p. 86.

17 Expressed by Oba Akenzua II to Bradbury, 1959, BS-42.

18 Bradbury 1959, p. 202.

BIBLIOGRAPHY

Abbass, Donna Kathleen 1972 'European Hats Appearing in Benin Art'. M.A. Thesis, Department of Anthropology, Southern Illinois University.

Agheyisi, Rebecca N. 1986 *An Ẹdo-English Dictionary*. Ethiope Publishing Corporation.

Alagoa, E. J. 1976 'The Niger Delta States and Their Neighbors 1600–1800' in *History of West Africa*, (eds.) J. F. A. Ajayi and Michael Crowder. pp. 371–72. Vol. I, 2nd edn. Columbia University Press.

Allman, R. 1898 'With the Punitive Expedition to Benin City', *The Lancet* 2 (July 3), pp. 43–4.

Andah, Bassey W. 1982 'Urban Origins in the Guinea Forest', *West African Journal of Archaeology* 12, pp. 63–71.

Babatunde, Emmanuel D. 1992 *A Critical Study of Bini and Yoruba Value Systems in Change: Culture, Religion, and the Self*. The Edwin Mellen Press.

Barnes, Sandra T. and Ben-Amos, Paula Girshick 1989 'Ogun the Empire Builder', in *Ogun, Old World and New*, (ed.) Sandra T. Barnes. Indiana University Press, pp. 39–64.

Bassani, Ezio and Fagg, William 1988 *Africa in the Renaissance: Art in Ivory*. The Center for African Art.

Beier, Ulli 1963 *African Mud Sculpture*. Cambridge University Press.

Ben-Amos, Paula Girshick 1968 *Bibliography of Benin Art*. Primitive Art Bibliographies, 6. Museum of Primitive Art.

Ben-Amos, Paula Girshick 1971 'Social Change in the Organization of Wood Carving in Benin City, Nigeria'. Ph.D. thesis, Anthropology Department, Indiana University.

Ben-Amos, Paula Girshick 1973 'Symbolism in Olokun Mud Art', *African Arts*, VI, 4, pp. 28–31, 95.

Ben-Amos, Paula Girshick 1975 'Professionals and Amateurs in Benin Court Carving', in *African Images: Essays in African Iconology*, (eds.) Daniel F. McCall and Edna G. Bay. Africana Publishing Co., pp. 170–89.

Ben-Amos, Paula Girshick 1976 'Men and Animals in Benin Art', *Man*, N.S., II, 2, pp. 243–52.

Ben-Amos, Paula Girshick 1978 'Owina N'Ido: Royal Weavers of Benin', *African Arts*, XI, 4, pp. 49–53.

Ben-Amos, Paula Girshick 1983a 'In Honor of Queen Mothers', in Ben-Amos and Rubin, pp. 79–83.

Ben-Amos, Paula Girshick 1983b 'The Powers of Kings: Symbolism of a Benin Ceremonial Stool', in Ben-Amos and Rubin, pp. 51–8.

Ben-Amos, Paula Girshick 1983 'Who Is the Man in the Bowler Hat? Emblems of Identity in Benin Royal Art', *Baessler-Archiv*, N.F. 31, pp. 161–83.

Ben-Amos, Paula Girshick 1984 'Royal Art and Ideology in Eighteenth-Century Benin', in *Iowa Studies in African Art*, (ed.) Christopher Roy, II, pp. 67–86.

Ben-Amos, Paula Girshick 1986 'Artistic Creativity in [the] Benin Kingdom', *African Arts*, 19, 3, pp. 60–3.

Ben-Amos, Paula Girshick 1988 'Ẹdo Ancestral Altars: Testimonials to a Life Well-Lived', in *Proceedings of the May 1988 Conference and Workshop on African Material Culture*, pp. 25–7.

Ben-Amos, Paula Girshick 1991 '"Sculptures et bronzes sont nos photographies d'antan": art et histoire au royaume de Bénin, Nigeria', *Arts d'Afrique Noire*, 80, pp. 29–42.

Ben-Amos, Paula Girshick 1994 'The Promise of Greatness: Women and Power in an Ẹdo Spirit Possession Cult', in *Religion in Africa*, (eds.) T.D. Blakely, W.E.A. van Beek and D.L. Thomson, James Currey and Heinemann, pp. 118–34.

Ben-Amos, Paula Girshick and Osarenren Omoregie 1969 'Keeping the Town Healthy: Ekpo Ritual in Avbiama Village', *African Arts*, 11, 4, pp. 8–13, 79.

Ben-Amos, Paula Girshick and Arnold Rubin (eds.) 1983 *The Art of Power/The Power of Art: Essays in Benin Iconography*. Museum of Culture History, UCLA.

Ben-Amos, Paula and John Thornton n.d., 'Civil War in the Kingdom of Benin 1689–1721: Continuity or Social Change?'.

Blackmun, Barbara 1983 'Reading A Royal Altar Tusk', in Ben-Amos and Rubin, pp. 59–70.

Blackmun, Barbara 1984 'The Iconography of Carved Altar Tusks from Benin, Nigeria', 3 vols. Ph.D. thesis, Department of Art and Art History, UCLA.

Blackmun, Barbara 1984b *Art as Statecraft: a King's Justification in Ivory*. Monographies Musée Barbier-Muller.

Blackmun, Barbara 1984b 'Royal and Non-royal Benin: Distinctions in Igbesanmwan Ivory Carving' in *Iowa Studies in African Art*, (ed.) Christopher Roy, II, pp. 81–115.

Blackmun, Barbara 1988 'From Trader to Priest in Two Hundred Years: The Transformation of a Foreign Figure on Benin Ivories', *Art Journal*, 47, 2, pp. 128–38.

Blackmun, Barbara 1990 'Obas' Portraits in Benin', *African Arts*, 23, 3, pp. 61–69, 102–4.

Blackmun, Barbara 1991 'Who Commissioned the Queen Mother Tusks? A Problem in the Chronology of Benin Ivories', *African Arts*, 24, 2, pp. 54–65, 90.

Blackmun, Barbara 1992 'The Elephant and Its Ivory in Benin', in *The Elephant and Its Ivory in African Culture*, (ed.) Doran Ross. Fowler Museum of Culture History, UCLA, pp. 163–83.

Boston, J. December 1962 'Notes on the Origin of Igala Kingship', *Journal of the Historical Society of Nigeria*, 2, pp. 3, 73–83.

Boston, J. 1969 'Oral Traditions and the History of the Igala', *Journal of African History*, X, 1, pp. 29–43.

Bradbury, R. E. 1959 'Divine Kingship in Benin', *Nigeria*, 62, pp. 186–207.

Bradbury, R. E. n.d. Notes on file at University of Birmingham Library. A series: Field notes, Benin City and surroundings, 1951/52; B series:

Notes on 35mm Film Series, 1958; BS series: Benin Scheme Field notes, 1957–61; R series: Files, n.d.

Bradbury, R. E. 1957 *The Benin Kingdom and the Edo-Speaking Peoples of South Western Nigeria*, International African Institute.

Bradbury, R. E. 1973 *Benin Studies*, (ed.) Peter Morton-Williams. Oxford University Press.

Burton, Sir Richard 1863 'An F.R.G.S.': 'My Wanderings in West Africa: A Visit to the Renowned Cities of Wari and Benin', *Fraser's Magazine*, LXVII, February, March, April, pp. 135–57, 273–89, 407–22.

Connah, Graham 1975a 'How Archaeology Can Supplement History: The Example of Benin,' in *Discovering Nigeria's Past*, (ed.) T. Shaw. Oxford University Press.

Connah, Graham 1975b *The Archaeology of Benin*. Clarendon Press.

Cordwell, J. M. 1952 'Some Aesthetic Aspects of Yoruba and Benin Cultures'. Ph.D. Thesis, Department of Anthropology, Northwestern University.

Cordwell, J.M. 1959 'African Art' in *Continuity and Change in African Cultures*, (eds.) W.R. Bascom and M.J. Herskovits, Phoenix Books, pp. 28–48.

Craddock, P.T. and Picton, John 1986 'Medieval Copper Alloy Production and West African Bronze Analysis – Part II', *Archaeometry*, 28, 1, pp. 3–32.

Curnow, Kathy 1983 'The Afro-Portuguese Ivories: Classification and Stylistic Analysis of a Hybrid Art Form'. Ph.D. thesis, Department of Fine Arts, Indiana University.

Dark, Philip J. C. 1973 *An Introduction to Benin Art and Technology*. Clarendon Press.

Dark, Philip J. C. 1975 'Benin Bronze heads: Styles and Chronology', in *African Images: Essays in African Iconology*, (eds.) Daniel F. McCall and Edna G. Bay. Africana Publishing Co., pp. 25–103.

Dark, Philip J.C. 1962 *The Art of Benin: A Catalogue of an Exhibition of the A.W.F. Fuller and Chicago Natural*

History Museum. Field Museum of Natural History.

Dark, P., Foreman, W. and B. 1960 *Benin Art*. Paul Hamlyn.

Dickerson, Sara Jane Hollis 1979 'Benin Artist Idah: Court Art and Personal Style', *Interdisciplinary Studies*, II, 2.

Dike, K. O. October 1959 'Benin: A Great Forest Kingdom of Medieval Nigeria', *The UNESCO Courier*, No. 10, pp. 12–14.

Duchâteau, Armand 1994 *Benin: Royal Art of Africa*. Prestel Verlag.

Egharevba, Jacob U. 1949 *Benin Law and Custom*, 3rd edition. C.M.S. Niger Press.

Egharevba, Jacob U. 1968 [1934] *Short History of Benin*, 4th edition. Ibadan University Press.

Eisenhofer, Stefan 1994 'Was the Report of James Welsh (1588) the First Account of Afro-Portuguese Ivory Carving in Benin City?' *History in Africa* 21, 409–12.

Ezra, Kate 1992 *Royal Art of Benin: The Perls Collection in the Metropolitan Museum of Art*. Metropolitan Museum of Art.

Fagg, William 1959 *Afro-Portuguese Ivories*. Batchworth Press.

Fagg, William 1963 *Nigerian Images*. Percy Lund, Humphries & Co.

Fagg, William 1970 *Divine Kingship in Africa*. British Museum Press.

Fagg, William July 1977 'The Great Belzoni', *West Africa*, 4, 1330–31.

Fraser, Douglas 1968 *Village Planning in the Primitive World* Studio Vista.

Freyer, Bryna 1987 *Royal Benin Art in the Collection of the National Museum of African Art, Washington, D.C.* Smithsonian Institution Press.

Galembo, Phyllis (ed.) 1993 *Divine Inspiration: From Benin to Bahia*. University of New Mexico Press.

Gallagher, Jackie 1983 '"Fetish Belong King": Fish in the Art of Benin' in Ben-Amos and Rubin, pp. 89–93.

The Art of Benin

Garlake, p. 1974 'Excavations at Obalara's Land, Ife, Nigeria', *West African Journal Of Archaeology*, 4, pp. 111–148.

Garrard, Timothy 1983 'Benin Metal-Casting Technology', in Ben-Amos and Rubin, pp. 17–20.

Goucher, Candace 1978 'Lead Isotope Analyses and Possible Metal Sources for Nigerian "Bronzes"' in *Advances in Chemistry*, 171, (ed.) G. F. Carter, pp. 278–92.

Henderson, Richard N. 1972 *The King in Every Man: Evolutionary Trends in Onitsha Ibo Society and Culture*. Yale University Press.

Herbert, Eugenia W. 1973 'Aspects of the Use of Copper in Pre-Colonial West Africa', *Journal of African History*, XIV, 2, pp. 179–194.

Hess, Catherine 1983 'Unconventional Carving: stones and coconut shells', in Ben-Amos and Rubin, pp. 41–48.

Hodgkin, T. (ed.) 1960 *Nigerian Perspectives: An Historical Anthology*. Oxford University Press.

Ikhuoria, I.A. 1984 'Rapid Urban Growth and Urban Land Use Patterns in Benin City, Nigeria', *Case Studies in Migration and Urbanization in Nigeria*, (eds.) Pius O. Sada and Animam B. Osirike. Department of Geography and Regional Planning, University of Benin.

Izevbigie, Alfred Omokaro 1978 'Olokun: a focal symbol of religion and art in Benin'. Ph.D. dissertation, Art History Department, University of Washington.

Johnson, Marion 1970 'The Cowrie Currencies of West Africa: Part 1', *Journal of African History*, XI, 1, pp. 17–49.

Jones, Adam (ed. and trans.) 1983 *German Sources for West African History*. Franz Steiner Verlag.

Jungwirth, Mechthildis 1968 *Benin in den jahren 1485–1700*. Verlag Notring.

Kaplan, Flora 1981 *Images of Power*. New York University Press.

Kaplan, Flora 1993 'Iyoba, the Queen Mother of Benin', *Art History* 16, 3, pp. 386–407.

Kelly, Bernice M. (comp.) and Stanley, Janet L. (ed.) 1993 *Nigerian Artists: A Who's Who and Bibliography*. Hans Zell Publishers.

LaDuke, Betty 1988 'Princess Elizabeth Olowu: Nigerian Sculptor', *Kalliope* 10, 1/2, pp. 110–18.

Landolphe, J.L. 1823 *Mémoires du Capitaine Landolphe, contenant l'histoire de ses voyages pendant trente-dix ans aux côtes d'Afrique et aux deux Amériques*, (ed.) J. S. Quesne. Arthus Bertrand.

Lopasic, Alexander 1965 'The "Bini" Pantheon Seen Through the Masks of the "Ekpo" Cult', *Réincarnation et vie mystique en Afrique Noire*, Colloque de Strasbourg 16–18 mai. Presses Universitaires de France.

Marshall, H. F. 1939 *Intelligence Report on Benin City*. Unpublished report in The Ministry of Local Government, Benin City.

Melzian, Hans 1937 *A Concise Dictionary of the Bini Language of Southern Nigeria*. Kegan Paul, Trench, Trubner & Co. Ltd.

Mendes-Pinto, Maria Helena 1983 Introduction and captions, *Os Descobrimentos Portugueses e a Europa do Renascimento*. Catalogue of the XVII Exposicao Europeia de Arte, Ciencia e Cultura in Lisbon. Conselho de Ministros.

Murray, K. C. *Catalogue of Exhibits in The Benin Museum Transferred from the Custody of the Benin Divisional Council to the Federal Department of Antiquities on 26th August 1960* [found in Bradbury, Notes R67 Benin Art].

Nevadomsky, Joseph 1984 'Kingship Succession Rituals of Benin, Part 3: the Coronation of the Oba', *African Arts*, 17, 3, pp. 48–57.

Nevadomsky, Joseph 1986 'The Benin Bronze Horseman as the Ata of Idah', *African Arts*, 19, 4, pp. 40–47, 85.

Nevadomsky, Joseph 1987 'Brass Cocks and Wooden Hens: Benin Art', *Baessler-Archiv*, n.f. 35, 1, pp. 221–47.

Nevadomsky, Joseph 1988 '"Kemwin-Kemwin": The Apothecary Shop in Benin', *African Arts*, 22, 1, pp. 72–83, 100.

Nevadomsky, Joseph 1992 'Doing the Art History of Benin: Ritual and Royalty in the Service of Art', paper presented at the Symposium on Approaches to Benin Art: Past, Present, Future. Metropolitan Museum of Art.

Nevadomsky, Joseph 1993 'Religious Symbolism in the Benin Kingdom', in *Divine Inspiration: From Benin to Bahia*, (ed.) Phyllis Galembo. University of New Mexico Press, pp. 19–32.

Nevadomsky, Joseph and Daniel Inneh 1983 'Kingship Succession Rituals in Benin, Part 1: Becoming a Crown Prince', *African Arts*, 17, 1, 47–54.

Obayemi, Ade 1976 'The Yoruba and Edo-Speaking Peoples and their Neighbors before 1600', in *History of West Africa*, (eds.) J. F. A. Ajayi and Michael Crowder, Vol. 1, 2nd edition. Columbia University Press.

Ombu, Jigekuma 1975 'Bibliography of the Art and Material Cultures of the Benin Kingdom from the Earliest Times to 1969', *Abh. und Ber. Staatliche Museum für Völkerkunde, Dresden*, pp. 169–213.

Read, C. H. and O. M. Dalton 1899 *Antiquities of the City of Benin and from Other Parts of West Africa in the British Museum*. William Clowes & Sons, Ltd.

Rosen, Norma 1989 'Chalk Iconography in Olokun Worship', *African Arts*, 22, 3, pp. 44–53, 88.

Rosen, Norma 1993 'The Art of Edo Ritual', in *Divine Inspiration; From Benin to Bahia*, (ed.) Phyllis Galembo. University of New Mexico Press, pp. 33–45.

Roth, Henry Ling 1968 [1903] *Great Benin: Its Customs, Art and Horrors*. Routledge and Kegan Paul Ltd.

Royal Gold Coast Gazette Tuesday March 25 1823 No. 21, Vol. 1, pp. 73–74.

Ryder A. F. C. 1969 *Benin and the Europeans 1485–1897*. Longman, Green and Co. Ltd.

Shaw, Thurston, 1965 'Spectographic Analyses of the Igbo and other Nigerian Bronzes', *Archaeometry*, 8, pp. 86–95.

Shaw, Thurston 1978 *Nigeria: Its Archaeology and Early History*. Thames and Hudson.

Struck, Bernard 1923 'Chronologie der Benin Altertümer', *Zeitschrift für Ethnologie*, 55, pp. 113–66.

Talbot, P. Amaury 1969 [1926] *The Peoples of Southern Nigeria*, II. Frank Cass & Co. Ltd.

Townsend, Richard Fraser 1979 *State and Cosmos in the Art of Tenochtitlan*. Dumbarton Oaks.

Tunis, Irwin L. 1979 'Cast Benin Equestrian Statuary', *Baessler-Archiv*, n.f. 27, pp. 389–417.

Tunis, Irwin 1981 'A Study of Two Cire-Perdue Cast Copper-Alloy Stools Found in Benin City, Nigeria', *Baessler-Archiv*, n.f. 29, pp. 1–66.

Tunis, Irwin 1983 'A Note on Benin Plaque Termination Dates', *Tribus*, 32, pp. 45–53.

van Nyandael, David 1705 'A Description of Rio Formosa, or, The River of Benin', in *A New and Accurate Description of the Coast of Guinea*, (ed.) William Bosman. J. Knapton.

Vogel, Susan Mullin 1978 'Art and Politics: A Staff from the Court of Benin, West Africa', *Metropolitan Museum Journal*, 13, pp. 87–100.

Von Luschan, F. 1919 *Die Altertümer von Benin* (3 vols.), Museum für Völkerkunde, Berlin.

Werner, O. 1970 'Metallurgische Untersuchungen der Benin-Bronzen des Museums für Volkerkunde, Berlin', *Baessler-Archiv*, n.f. XVIII, 1, pp. 71–153.

Werner, O. and Willett, F. 1975 'The Composition of Brasses from Ife and Benin', *Archaeometry*, 17, 2, pp. 141–56.

Willett, Frank 1967 *Ife in the History of West African Sculpture*. Thames and Hudson.

Willett, Frank 1973 'The Benin Museum Collection', *African Arts*, VI, 4, pp. 8–17.

Willett, Frank and Fleming, S. 1976 'A Catalogue of Important Nigerian Copper-Alloy Castings Dated by Thermoluminescence', *Archaeometry*, 18, 2, pp. 135–46.

Willett, Frank, Torsney, Ben and Ritchie, Mark 1994 'Composition and Style: an Examination of Benin "Bronze" Heads,' *African Arts*, 27 (3), pp. 60–67.

Williams, Denis 1974 *Icon and Image: a study of sacred and secular forms of African classical art*. New York University Press.

Photo Acknowledgements

The author and British Museum Press would like to thank the museums and private collectors who allowed works from their collections to be reproduced in this book. They would also like to thank the museums and photographers who provided photographs.

Individuals

Ben-Amos, Paula G. 2, 8, 9, 32, 48, 49, 51, 53, 57, 58, 59, 60, 61, 62, 66, 67, 68, 69, 74, 78, 81, 87, 89, 90

Blackmun, Barbara 46

Bradbury, Ros 100

Cordwell, Justine 4

Dickerson, Sara 45

Hewitt, J. 38

Willett, Frank 16, 20, 22, 28, 65 (photos © Frank Willett, objects in 16, 20 from collections of National Museums of Nigeria)

Museums

The British Museum, Dept. of Ethnography, Museum of Mankind 1, 5, 17, 18, 19, 21, 24, 26, 27, 30, 33, 36, 40, 70, 75, 77, 79, 84, 86, 88, 91, 92, 93, 94, 95, 96, 98, 99, front cover
Eliot Elisofon Photographic Archives, National Museum of African Art, Smithsonian Institution, Washington D.C. 39, 52, 85, 94

The Field Museum of Natural History, Chicago 7, 42, 64, 73

The Metropolitan Museum of Art, New York, Perls Collection 23, 34 (photo © Benyas Kaufman), 47, 54, 60, 63, 82

National Museums of Nigeria 14, 16, 20, 72

National Museums and Galleries on Merseyside, Liverpool Museum 25

Museum für Völkerkunde zu Leipzig 15, 44, 55

Museum für Völkerkunde, Vienna 10, 29

Museum Rietberg, Zürich 11

Pitt Rivers Museum, Oxford 3, 13, 44, 83

The Royal Collection, © Her Majesty the Queen 71, back cover

Sainsbury Centre for Visual Arts, University of East Anglia 97

Staatliche Museen zu Berlin – Preussicher Kulturbesitz Museum für Völkerkunde 35, 37a and b

The University of Pennsylvania Museum 6, 12, 31, 41, 76, 80

INDEX

Numbers in **bold type** refer to Figures.